FIREPLACES

FIREPLACES

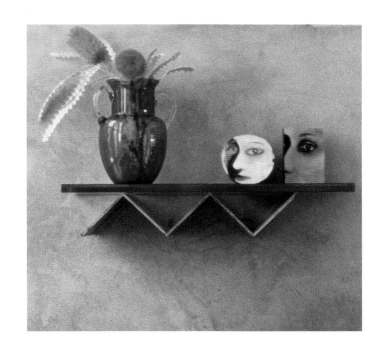

Photographs by Cookie Kinkead
Text by Alexandra Edwards
Foreword by Paul Vincent Wiseman

Chronicle Books San Francisco

Acknowledgments

We would like to thank all those who partici-
pated in this project with special thanks to Jody
Thompson-Kennedy, Paul Wiseman, Brett Landen-
berger and Scott Waterman, Sue Fisher King,
Roberto Varriale, Ann Jones, Cevan Forristt, Karen
Thompson, Steven Shortridge, Lewis Stan and New
Lab, and David Barich.

Foreword photo: Architect John Hood chose a neoclassic
approach for the fireplace in his Mill Valley home. The hearth and
inner face, which is pedimented, are both granite. A decorative
band running the length of the mantel with a pattern of dentils
echoes the cornice above the bookshelf and is used as a motif in
other sections of the house.

Printed in Hong Kong
Book and cover design by Karen Pike
Typesetting by T:H Typecast, Inc.
Library of Congress Cataloging-in-Publication Data

Edwards, Alexandra.
 The fireplace book / by Alexandra Edwards;
photographs by Cookie Kinkead.
 p. cm.
 ISBN 0-8118-0212-4 (hc). —
 ISBN 0-8118-0156-X (pb)
 1. Fireplaces. I. Title.
NA3050.E38 1992
721'.8—dc20 91-39656
 CIP

Distributed in Canada by Raincoast Books,
112 East Third Avenue, Vancouver, B.C. V5T 1C8

10 9 8 7 6 5 4 3 2 1
Chronicle Books
275 Fifth St.
San Francisco, CA 94103

C O N T E N T S

To my parents, John and Cooba Sale.
A.E.

It is with all my love that I dedicate this book to my parents
Zillah and Dick Kinkead... and to my sisters Nicky and Trudy,
my brother-in-law Michael, my nieces Taya, Anna Lise, and
Alexa, and to Terry Dollard. Thank you all for being who you are.
Cookie

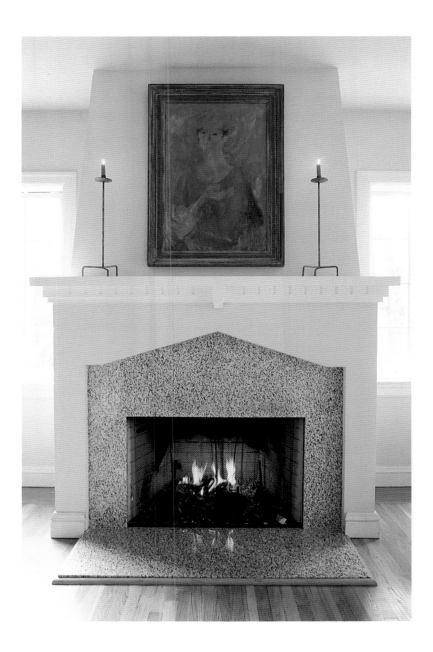

FOREWORD

The fireplace has traditionally been the decorative and domestic focus of every home. The ancient Greeks gave the fireplace a special relevance by ascribing to its own goddess, Hestia. Personally, I have a great affection for fireplaces—they provide an elemental source of comfort and warmth. Perhaps the happiest memories we all have of childhood come from scenes around the hearth.

In a way, the fireplace is the ultimate symbol of our own humanity. When we see someone cold and suffering on the street, our immediate instinct is to provide shelter and warmth—to take that person and place him or her in front of a brightly lit fireplace. It's not surprising that in Charles Dickens's novels, the true face of charity and enlightenment is symbolized by family gatherings around the hearth.

As a designer, when I begin working on somebody's residence, I am frequently drawn to the fireplace as the pivotal point from which inspiration emanates. This holds equally true for an apartment in a New York high-rise, a mountain retreat in Colorado, an English-style manor home in Pasadena, a Victorian flat in San Francisco, or a country get-away in the Napa Valley.

This book takes us on a journey from the traditional home to late twentieth-century eclectic design, where the fireplace is not only the center of the room, but is also the owner's expression of individuality. In a world that is constantly trying to make us all the same, self-expression has been forced to take on many new twists, as has the design of the fireplace.

While you take this visual journey, note the remarkable diversity, yet singular function, of these expressive works of art. The fireplace will always be a center for human gatherings, but now it can be as unique as those who gather around it.

Paul Vincent Wiseman

Maison sans flamme, corps sans âme.

French proverb

No place is more delightful than one's own fireside.

Cicero, c. 40 B.C.

INTRODUCTION

The mere mention of a fireplace conjures a host of pleasing associations—the romance of a flickering flame, a warm, welcoming glow on a wintry evening, the smoky fragrance of dying embers. There is something reassuringly elemental and real about wood burning in a grate, for who among us is not drawn to a lighted fire, around which, after all, we have gathered since the dawn of human history?

There is nothing like a fire to enhance the mood of a social occasion or to offer companionship during a moment of solitude. How comforting it is to contemplate a calmly smoldering hearth, and what could be more stirring than a great roaring log fire, crackling and blazing with panache?

This desire for reassuring comfort and warmth may well be a part of how we deal with the vicissitudes of life today, part of a trend toward turning inward.

Whatever the reason, it is not news that there is a resurgence of interest in the fireplace as a design element and architectural detail. A fireplace is the natural focal point of a room. It can make a statement, pull a room together, jazz up an otherwise bland interior, or provide an excuse to let one's imagination run a little wild. It can also be a relatively easy way to upgrade a space. Once tucked away in a wall, today's fireplace has broken free and can be placed just about anywhere we wish. No longer of necessity purely functional, it may fulfill a decorative or symbolic need.

Most architects and designers relish the challenge and freedom of designing a fireplace. The result can stand out on its own, assume the status of a piece of art or be incorporated into its architectural and stylistic surroundings. Fireplaces are being given new attention and are taking on a starring role in hotel lobbies, restaurants, bars, and even boutiques.

With the great range of design styles available today, there is no excuse to feel limited when framing a firebox. Whether classical or contemporary, functional or fake, baroque or baronial, the choices are virtually inexhaustible. We need not be constrained, either, by choice of materials, for these are legion. Cast stone with a dazzling array of pigments, malleable metals, tiles, granites, and marbles of all hues and provenance, as well as faux painting techniques aplenty, are all available for experimentation.

Many artists and craftsmen are turning their creative talents toward the hearth. Artist Karen Thompson hoards shards of pottery, colored glass and even old watch faces for her lively mosaics, which she applies in clever, quirky ways to her patrons' firesurrounds, mantels, or hearths. Roberto Varriale's Tuscan farmhouse re-creations are tempting enough without a firebox.

We need not be disheartened if we cannot afford antique mantelpieces or fine marble. There are reproductions available covering every period and design. The humblest of hearths, too, can have its own appeal or, if needed, be transformed with imaginative dressing. There are no rules to be followed apart from one's own instinct and sense of style. A mantel can be the repository for treasures or bric-a-brac, provide a backdrop for an ever-changing display of objets d'art, varying from the cluttered to the artfully stark, from the mundane to the unexpected. We selected some of our favorite versions and gave some designers the opportunity to demonstrate different approaches.

Liberated from the drudgery of coal buckets and sooty embers by the convenience of gas and electricity, we can now indulge in the luxury of fireplaces in hallways, in kitchens, in dining rooms, and in bedrooms—perhaps the ultimate in romance. We don't even have to go as far as the real thing. With the simplest of materials, a bit of imagination, and a touch of trompe l'oeil, we can get by on illusion. The whole concept of a fireplace as we know it can be transcended, as Linda Chase has done with her antique garden ornament wire mantelpiece that she covered with moss.

This is a book of possibilities. We offer ideas, not a set of rules. We hope you will be inspired by the examples we have collected in the following pages. To quote William Cowper: "Now stir the fire and close the shutters fast, let fall the curtains, wheel the sofa round" . . . and enjoy!

A TOUCH OF ROMANCE

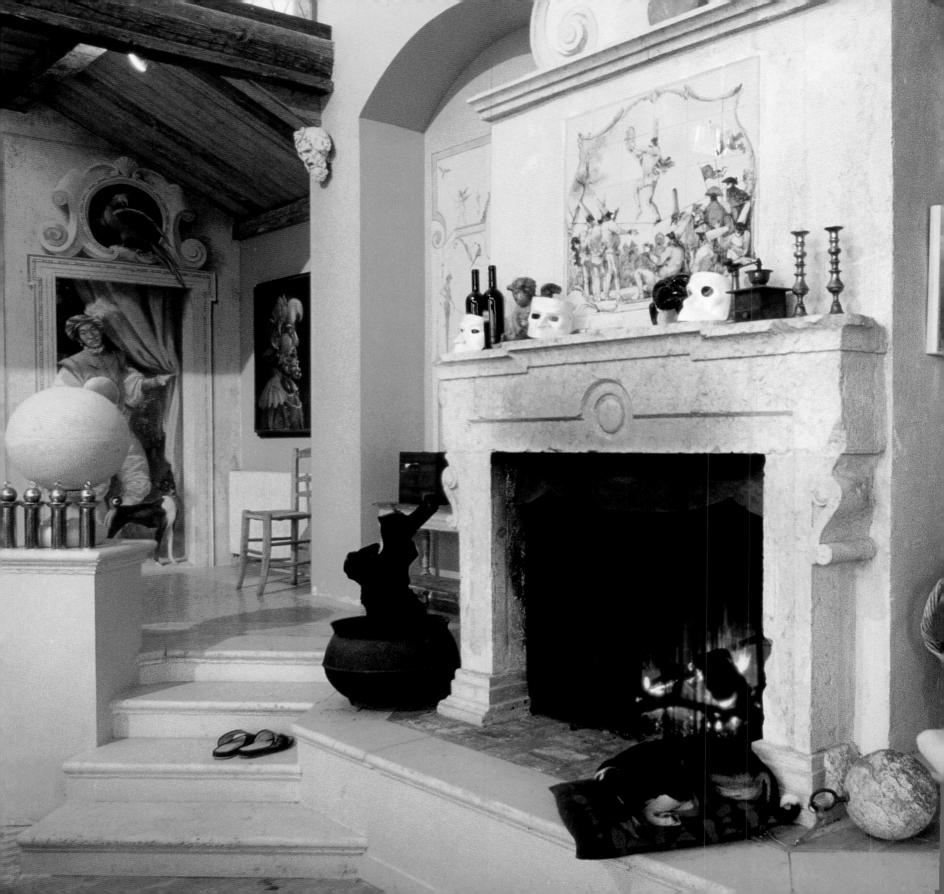

The whole notion of a fireplace is readily recognized as romantic—a lighted fire is an invitation to linger, to slow down, to relax. When the lights are dimmed, who can fail to be beguiled by fireglow? We have central heating for physical warmth, but we still crave a fire to fill some deep emotional need.

Anywhere we place a hearth that might be unexpected, or somewhat self-indulgent—a bedroom, a bathroom, or perhaps a pool house—is instantly imbued with a sense of romance. It helps, of course, if we have a pretty Baroque French mantelpiece or an elegant Italian marble firesurround, but even the humblest of hearths can be rendered romantic when embellished with a selection of dried roses, generous vases of fresh-cut flowers, candles, or evocative pictures.

Artist Karen Thompson bejewels her firesurrounds with shards of ceramics and glass marbles, which reflect the light in exciting ways. Interior designer Dian Burn, whose style is informed by a romantic sensibility, employs Corinthian columns and eighteenth-century antiques and delicate *boiserie* to accompany her mantelpiece. A large rustic fireplace may seem an unlikely candidate for romance, but when fashioned to transport you to some Italian country villa, and placed in a room filled with muralist Carlo Marchiori's extraordinary double-story frescoes, it will surely qualify.

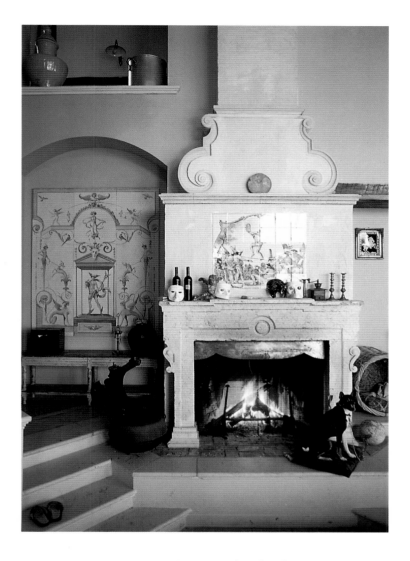

MARCHIORI/VARRIALE A commanding fireplace competes for attention in artist Carlo Marchiori's mural-filled country house and studio. "I like to think of Ca'Toga as a decayed rural villa in Italy," he says of his unique part Palladian villa, part Venetian palazzino, part barn. Fellow Italian Roberto Varriale built this massive, stone, hooded version for the two-story-high living room, incorporating the hearth into steps leading down into a sunken seating area. Tiles set into the chimney are Marchiori's own work, featuring his favorite commedia dell'arte figures.

CANDACE BARNES

Interior designer Candace Barnes was given this one-of-a-kind copper and brass screen, now gracing the fireplace in her living room, by furniture designer John Hutton. Hutton had made the piece for an Egyptian exhibit at the San Francisco Museum of Modern Art. The unfussy, yet elegant lines of the limestone mantelpiece, which Barnes purchased locally, are given an appealing warmth by the eclectic choice of objects dressing the mantel and hearth.

WENDY TSUJI

This charming fireplace was designed for a pool cottage by architect Wendy Tsuji. The cottage, only four hundred square feet, was designed with foot-thick nine-foot-high doors that fold away into pockets. In summer the doors are often pocketed away, and the cottage becomes a pavilion. In winter when they are closed, the fireplace heats the whole cottage. Its firebox level with the floor, the fireplace is set out from the wall with tapering sides, its simple, pleasing lines softened by a decorative French panel on which are hung bunches of dried flowers. The owner, a collector and patron of art, found the panel in Italy and the fire-back, whose curving lines offset the regularity of the brick coving, in France.

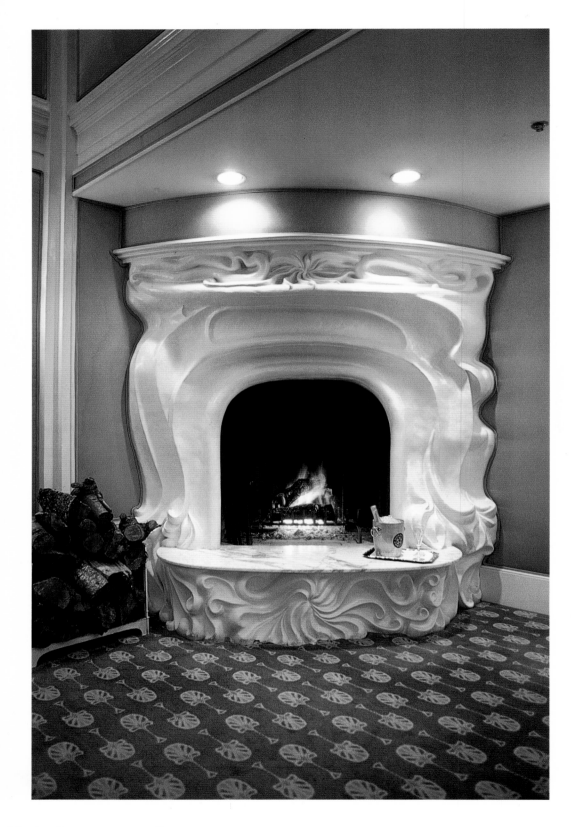

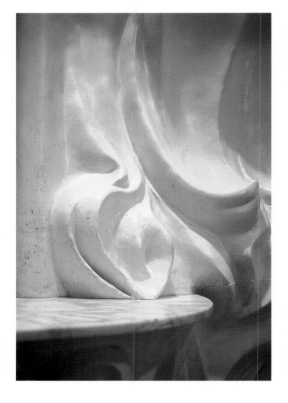

MANUEL PALOS

Sculptor Manuel Palos was asked to come up with an interpretation of an Art Nouveau fireplace for the lobby of the Galleria Park Hotel in San Francisco. Palos was given complete artistic freedom and has produced a warmly sinuous fluidity of line. Hand-crafted in gypsum-reinforced concrete, with a raised marble hearth, the ten-foot-tall structure was created, without a model, in sections. A log fire is kept burning in the grate all through the day, a feature common to all the hotels in the chain.

ROBERT HUTCHINSON

Designer Robert Hutchinson built his home on the theme of geometric shapes that "extend three-dimensionally into all kinds of forms throughout the house." Hutchinson constructed a study fireplace with a series of stone shapes extending into the room to provide a play of light. The asymmetrical design was kept simple to best complement the designer's eclectic collection of artifacts, amassed in the bordering case. The piece above the hearth is a rare first-century Roman Palmerian figure from Syria.

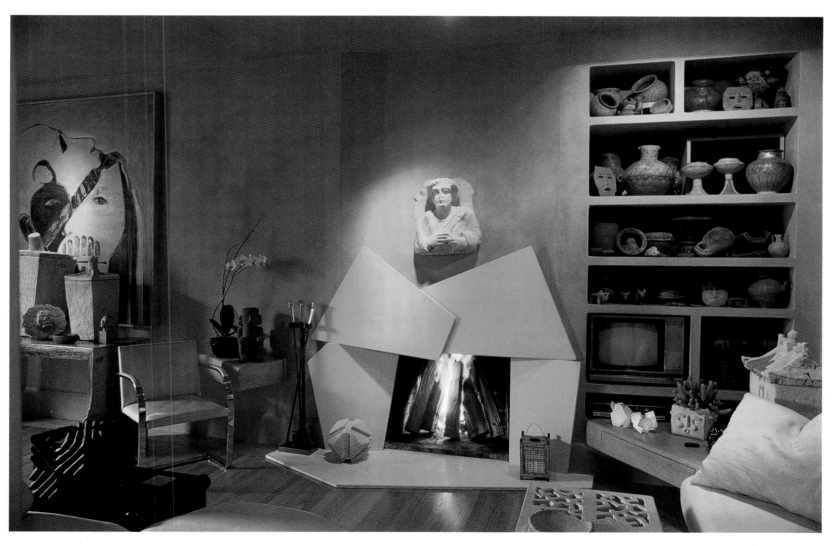

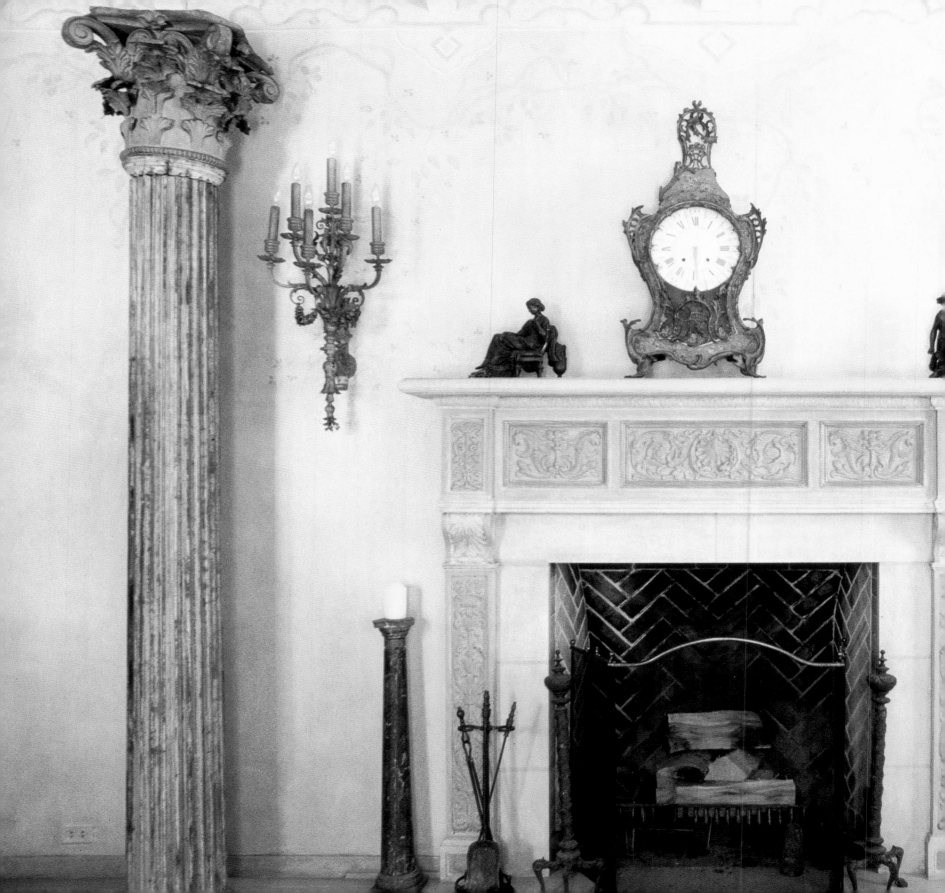

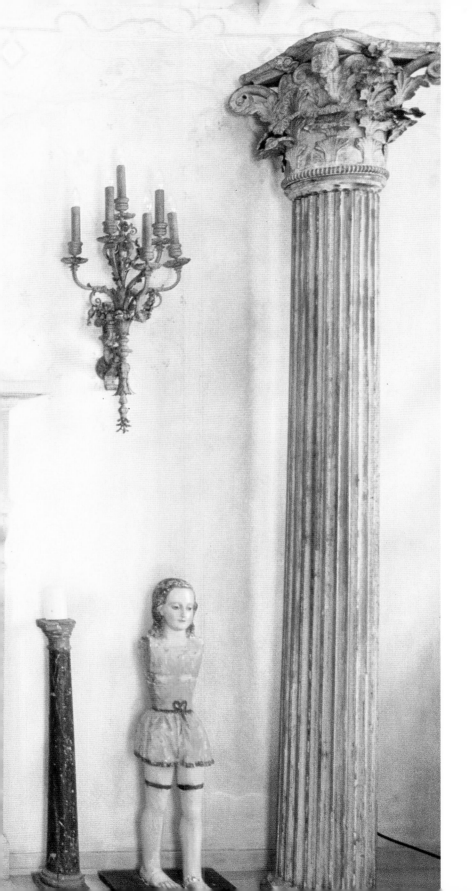

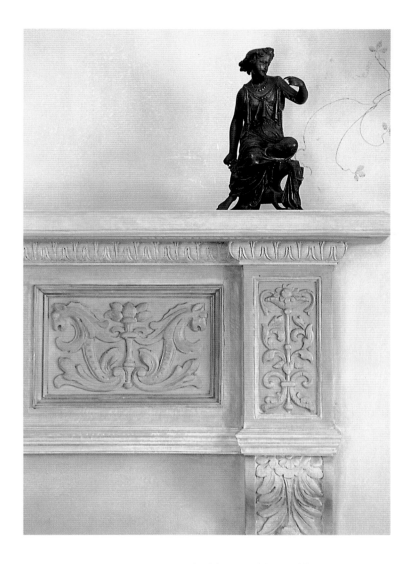

DIAN BURN In the library of her richly romantic, eighteenth-century–inspired Los Angeles home, interior designer Dian Burn placed a treasured pair of French Corinthian columns on either side of the carved wood Italian mantelpiece. Burn wanted a moody, mystical, not-of-this-century feel to the room—her favorite—and to help achieve this transformation, (the room formerly had dark lacquered ceilings) longtime associate painter Karin Linder gave the walls their hand-glazed finish, also applying her brush to the mantelpiece. The bronze nineteenth-century sconces are original to the house, the clock Louis XV.

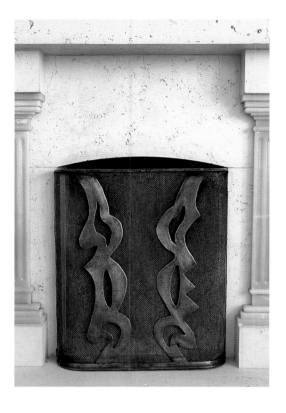

ROBERTO VARRIALE

Former gallery owner Carla Baird chose an unusual fireplace all in onyx for her spacious bedroom. When the header broke in transport, she called on the artist and stone caster Roberto Varriale to incorporate what was salvageable into a stone surround of his own design. Varriale picked up the butterscotch tones of the onyx for the stone and recessed lights behind the onyx portions of the jambs, which are set in brackets for access. The result is a pretty, classically proportioned fireplace that nicely complements its elegantly appointed setting. The screen is by Susanne Wibroe.

LINDA CHASE

When interior designer Peter Carlson found a rare antique English wire mantelpiece (used in gardens in the eighteenth-century for topiary or trailing ivy) in London, his partner Linda Chase, captivated by its charm and recognizing its potential, immediately went about reproducing a whole line of wire garden ornaments, including chairs and sofas. For this sample version, she asked flower shop owner Clifford Miller to cover the mantelpiece in moss and, in a gesture of pure romance, placed it in a formal setting indoors, setting the tone with a pair of eighteenth-century Italian sconces.

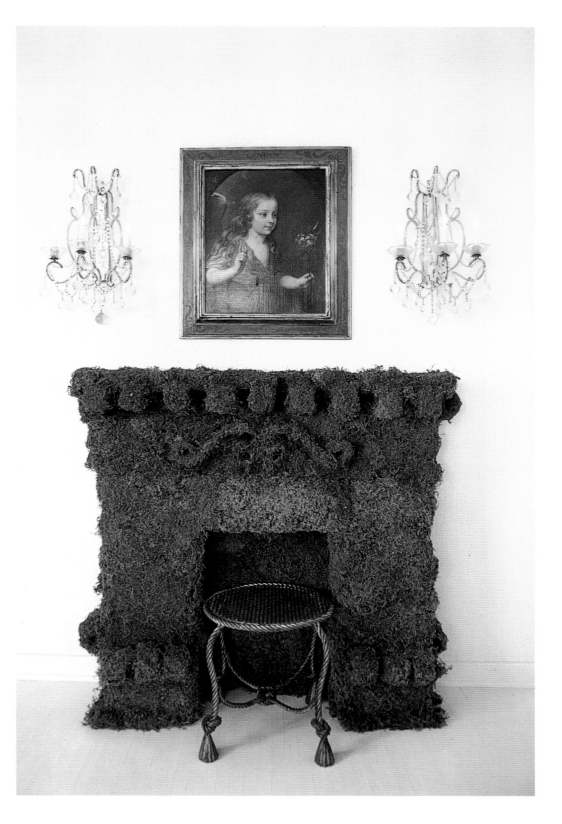

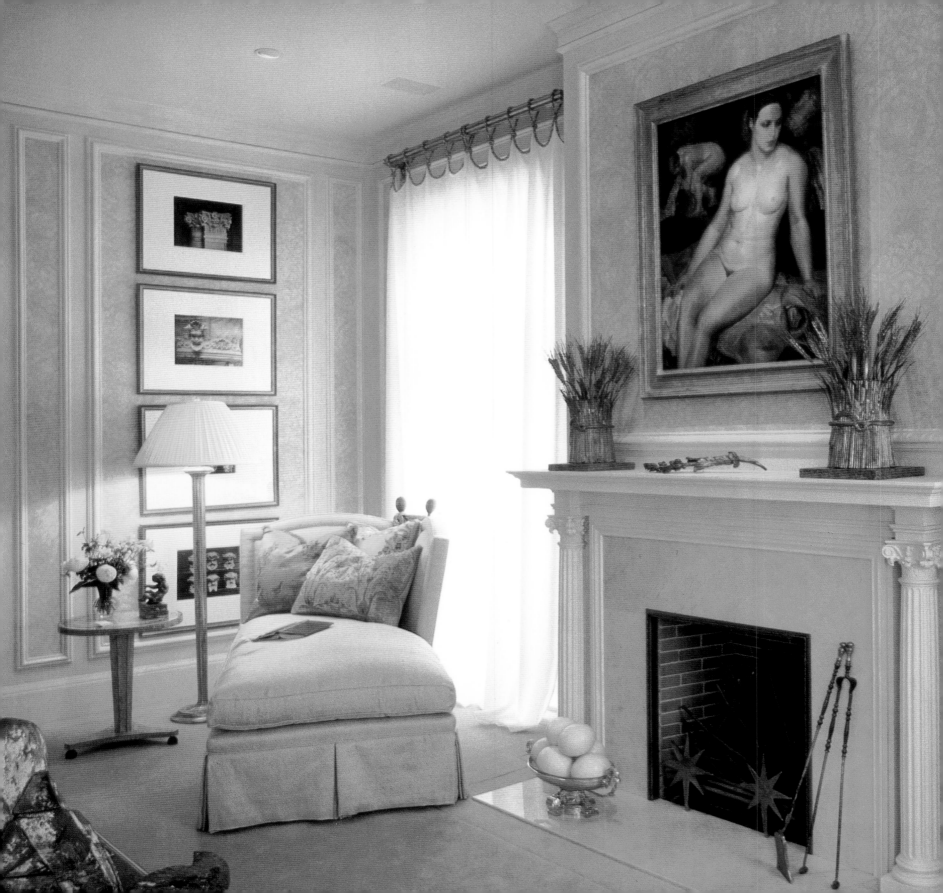

PAUL VINCENT WISEMAN Paul Vincent Wiseman's genius as a designer lies in his ability to "interpret" his clients; for Wiseman "appropriateness" is all-important. For the pretty, neoclassically informed fireplace, Wiseman stripped the tiled firesurround, replacing it with marble and adding touches of restrained elegance in his choice of mantel dressing and andirons.

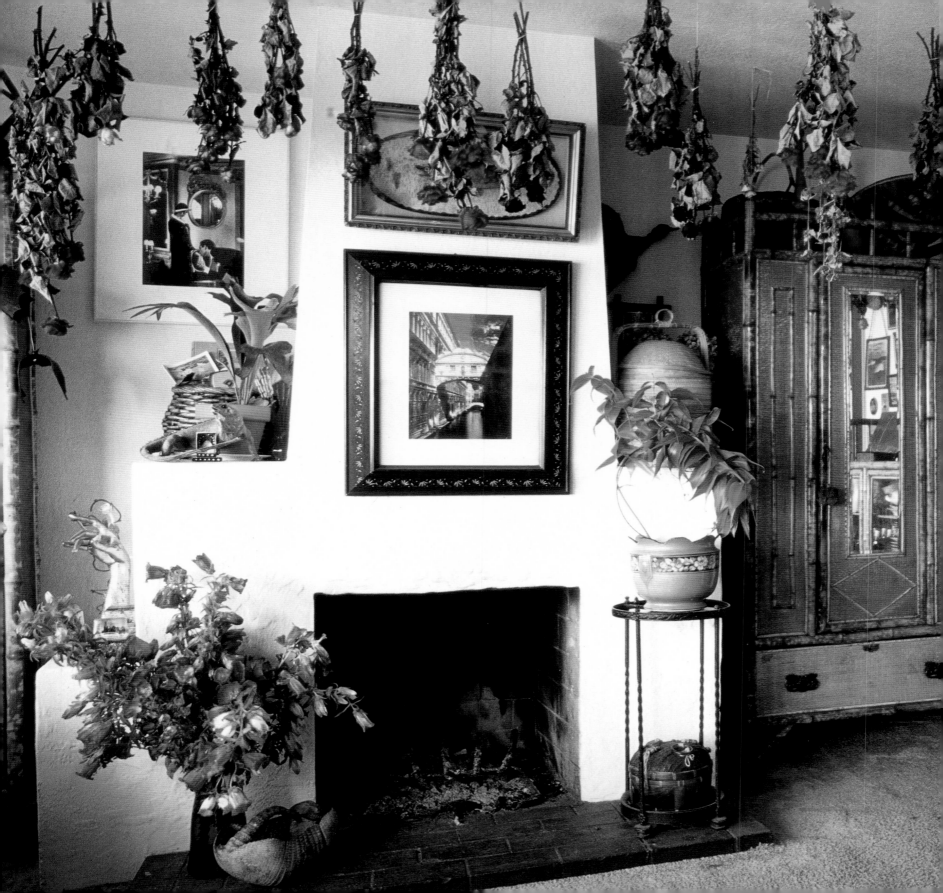

KATHY DOOLEY Kathy Dooley, owner of Columbine, a delightfully eclectic florist's shop in San Francisco, who also crafts mirrors, frames, hearts, and other whimsy using moss, twigs, and dried roses, hangs the tools of her trade about her own simple cottage hearth. "I'm into the Victorian thing," she says, "but the eccentric side, not the fussy." Dooley has placed various bric-a-brac on the stepped-in sides of the chimney, on which she has also hung photographs and a framed stuffed trout.

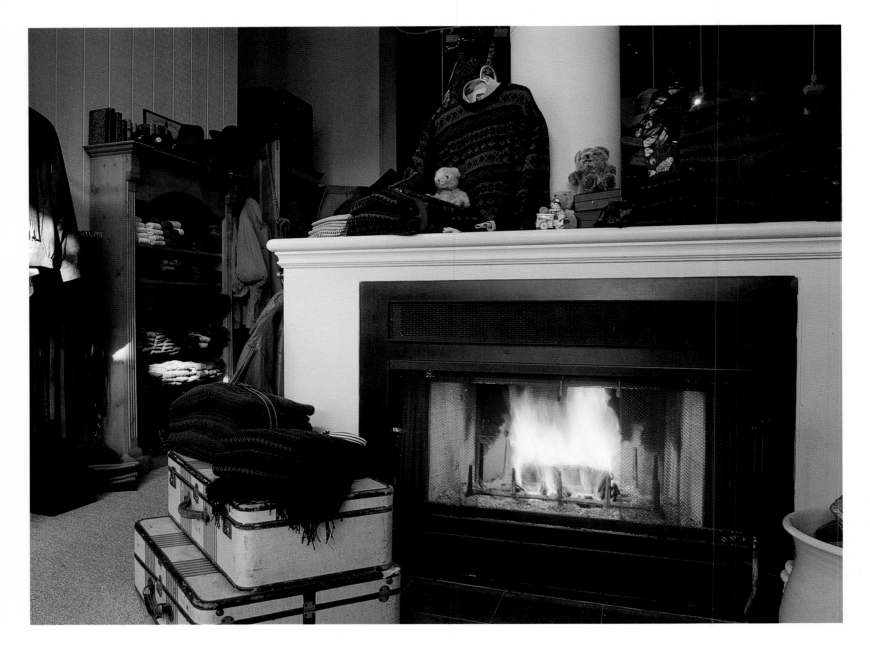

BUTTON DOWN The owners of Button Down, a clothing boutique in San Francisco, decided to include a fireplace in the interior scheme, placed to form an immediate focus for anyone entering the store. They use the fireplace frequently, claiming that it creates an inviting and intimate atmosphere for their clients.

JOAN CROWLEY

Books are an obvious accompaniment to a fireplace, and this charming antique French limestone mantelpiece gracing a light-filled living room is flanked by floor-to-ceiling bookshelves. But, for a somewhat unexpected touch, the owner, who has furnished her house with a successful mix of antiques and folk art, has draped a pair of rustic ladders with hand-woven shawls from Guatemala, adding a splash of vibrant color.

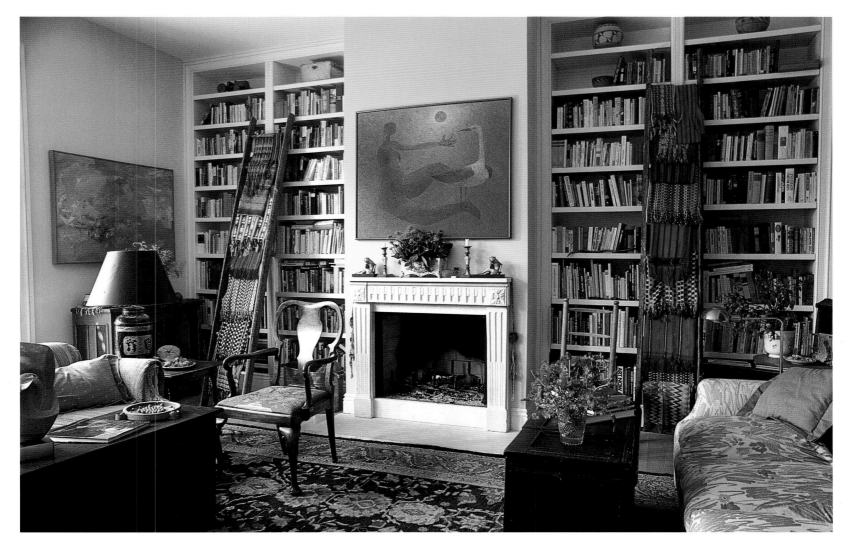

Outdoor and Kitchen Hearths

◆◆◆◆◆◆◆◆◆◆◆◆◆◆◆◆◆◆◆◆◆◆◆◆◆◆◆◆◆◆◆◆◆◆◆◆◆◆◆

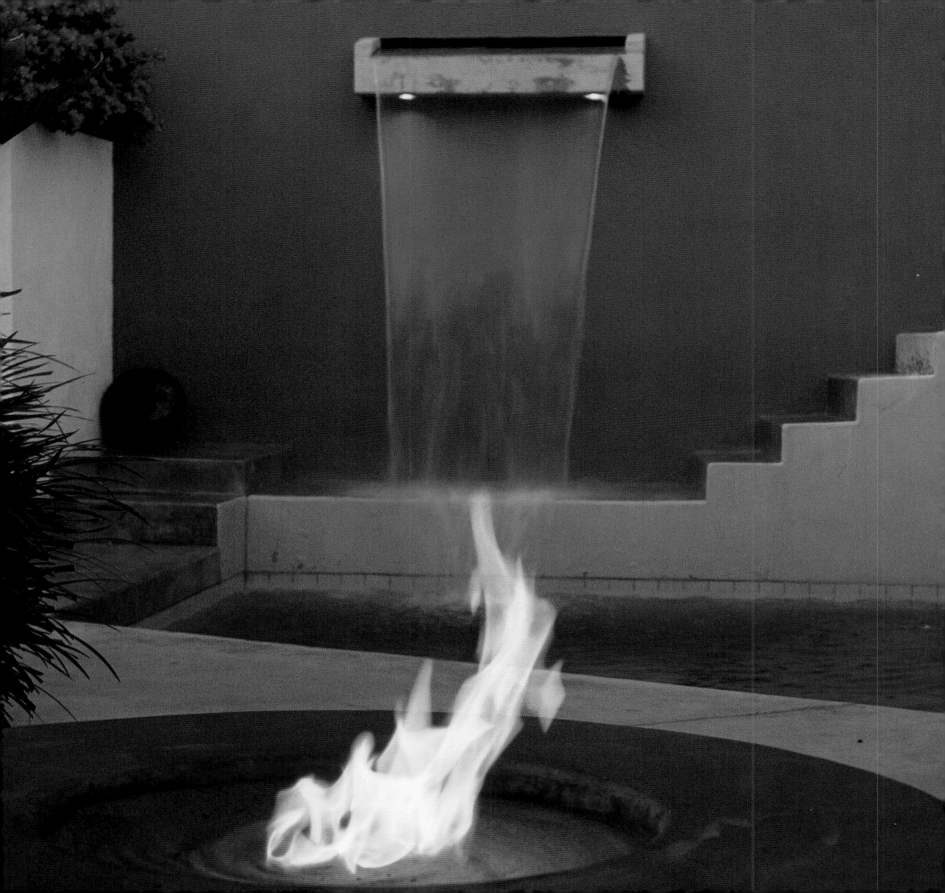

Most of us will readily admit to a love of the outdoors. Urbanites may snatch as much as possible of this precious commodity, even if it means being perched precariously on a ledge of a balcony twenty stories up. We build sunrooms and capacious decks; we carve out gardens where we can. Whether city or country folk, most of us cherish the idea of "escape" to the country; and central to this notion is the outdoor fire. Gathering around a fire at dusk, whether in the wilderness or outside our own homes, seems only natural. When the air of an evening is fragrant with the odors of mesquite coals and grilling food, summer has surely arrived.

Whether for barbecuing, simple indulgence, or warmth, we barely need an excuse for constructing an outdoor fireplace. A whole genre of entertaining has blossomed around outdoor cooking, synonymous with summer, relaxation, good eating, and conviviality.

An outdoor fireplace can be as simple as fitting a rack over a collection of blocks—or as lavish as an indoor hearth, incorporating decorative niches and sophisticated grilling devices. It can add a focal point to terraces, decks, and outdoor rooms. We can approximate a natural setting as closely as possible, or re-create an interior landscape outdoors.

With increasing culinary sophistication and interest in ethnic foods and authentic cooking methods, open hearths and brick ovens are becoming more popular in the home kitchen. Whether we are professional chefs or merely enthusiastic amateurs, a hearth in the kitchen is as good as a promise of good food, lending a welcome homeliness to an array of high-tech appliances.

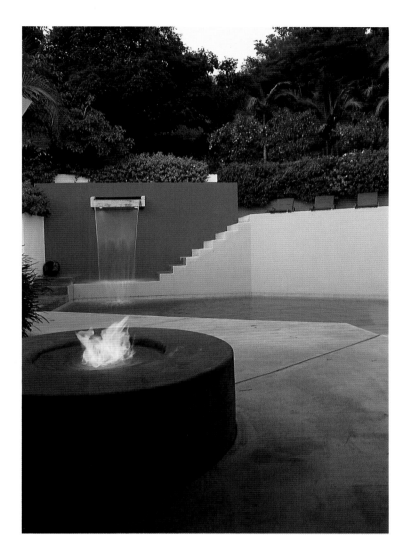

LUIS ORTEGA There is something potently elemental about this outdoor fire pit, with its Zen-like simplicity of form. It was conceived as part of a poolscape representing the four elements by Los Angeles architect Luis Ortega, who also sees his design as an homage to Mexican architect Luis Barragan with a wall of brilliant blue behind the waterfall. A gas ring, buried in the sand with perforations on its underside, leaks gas upward. Controlling the flow of the flame changes its mood and color, from a soft orange red to steely blue. Playing with patterns in the sand also affects the form of the flame.

ROBERTO VARRIALE

Stone caster Roberto Varriale designed and built a series of terraces set into a steep hillside behind the home of architect Howard Backen, of the San Francisco firm of Backen-Arrigoni & Ross. The terraces, with their roof canopies, are designed to act as optional rooms. Varriale incorporated an outdoor fireplace and grill into the wall of the lower terrace, synthesizing its design elements and mirroring the dual function of the indoor-outdoor space. Varriale favors bold colors that remind him of his native Italy, which he has employed to great effect in the flooring of the terrace.

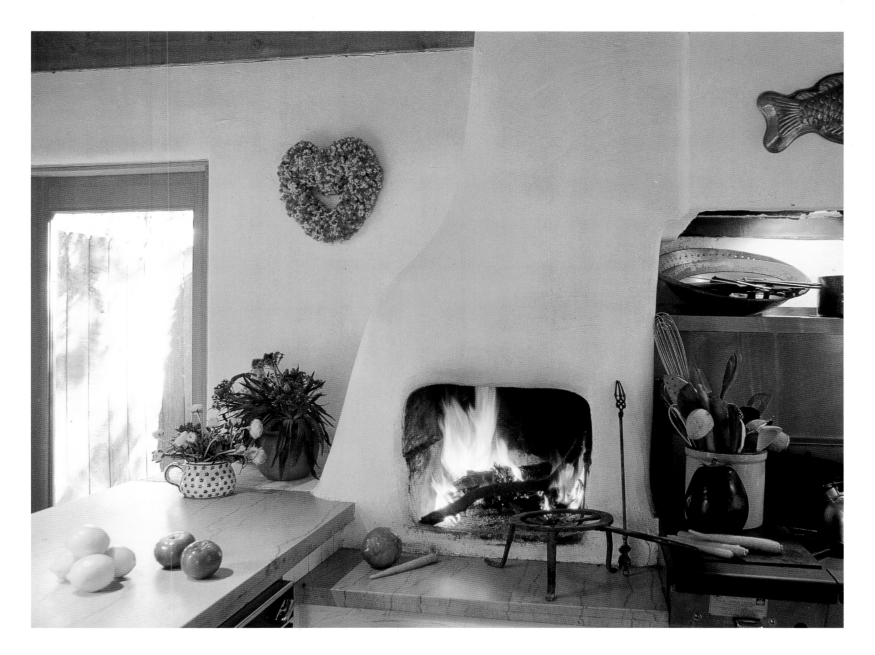

JAMES & GILLIAN SERVAIS James & Gillian Servais are very fond of their kitchen fireplace. "It's part of our life, and we use it almost every other day," says James. A true masonry, small, beehive-style fire nestled in the corner of the room, it is fitted with a rack for grilling.

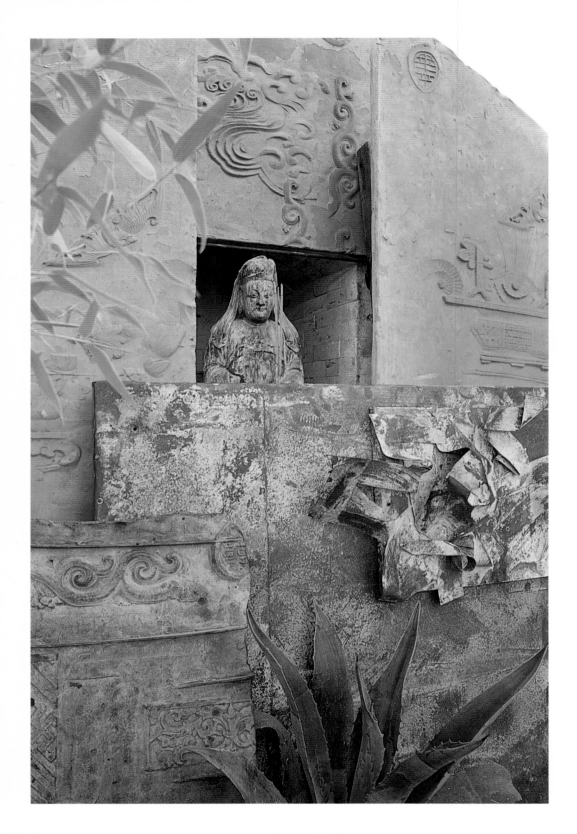

CEVAN FORRISTT

Landscape gardener Cevan Forristt used terra-cotta wall panels he cast himself to frame an impromptu outdoor fireplace in his garden in San Jose. The garden, with its varieties of Asian pears, pots of towering bamboos, bonsai trees, and ingeniously contrived waterfalls set among columns, wall remnants, and wooden gateways, resembles some hybrid oriental garden in a state of ruin. A master of ambience and making use of what is at hand, Forristt turned an old kiln into a firebox. This talented gardener gathers inspiration and artifacts from his extensive travels in the Far East. The fireplace continues to evolve as he brings in a potted palm and adds copper sculpted panels and a wooden Buddha.

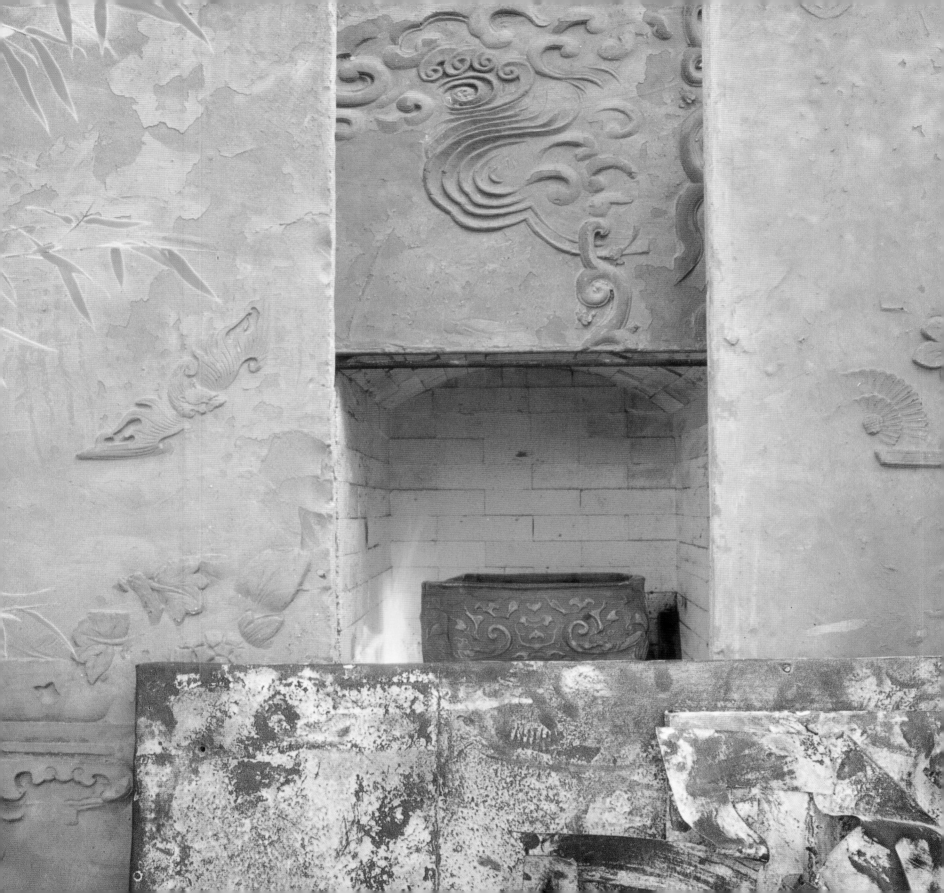

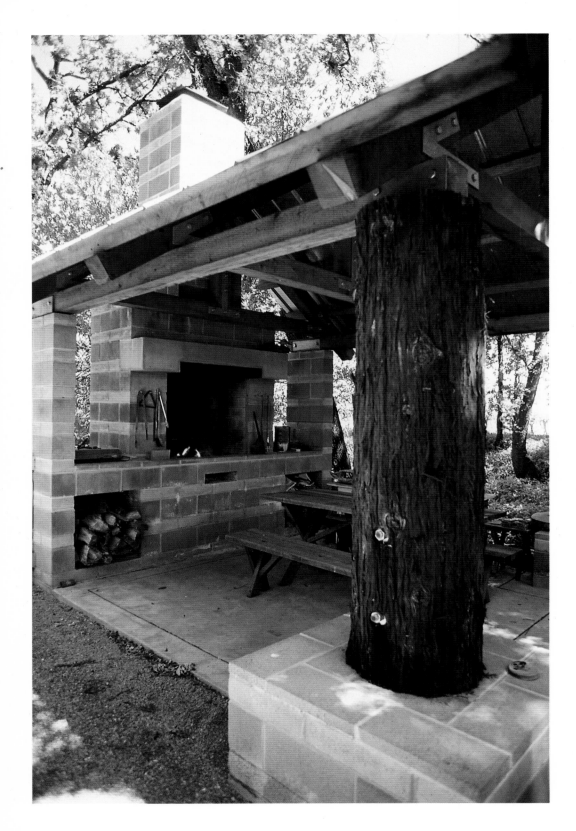

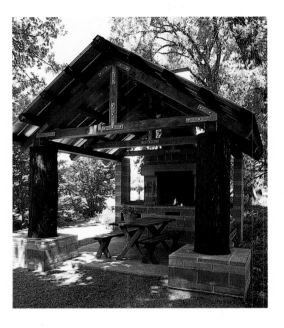

FERNAU & HARTMAN

Architects Laura Hartman and Richard Fernau created an outdoor fireplace and barbecue with a supporting pavilion-style structure in the oak tree-shaded garden of painter Helen Berggruen's country home and studio. The fireplace is built with alternating stripes of red and gray concrete blocks. "The idea was to claim the yard in front," says Hartman, "to set a defining line between house and barbecue." The house, with its cottage-proportioned rooms and master bedroom and studio set in a tower, has a delightfully informal feel to it. The areas outside act as an extension of the indoors.

EDWARD GRENZBACH

Although not strictly speaking in an outdoor setting, this see-through fireplace in a Malibu home designed by architect Edward Grenzbach, with its large open niche above allows the owners to enjoy the double benefits of a fire and a view of beach and ocean, as if they were outside. Largely ceremonial, the fireplace is set in from the extensive plate glass windows. A gas ring buried in sand emits a flame while ensuring that the view will be unimpeded by logs.

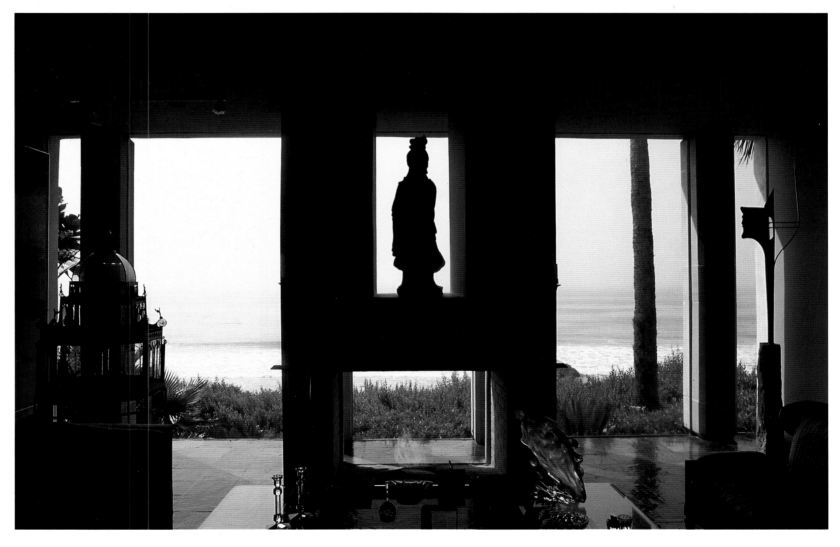

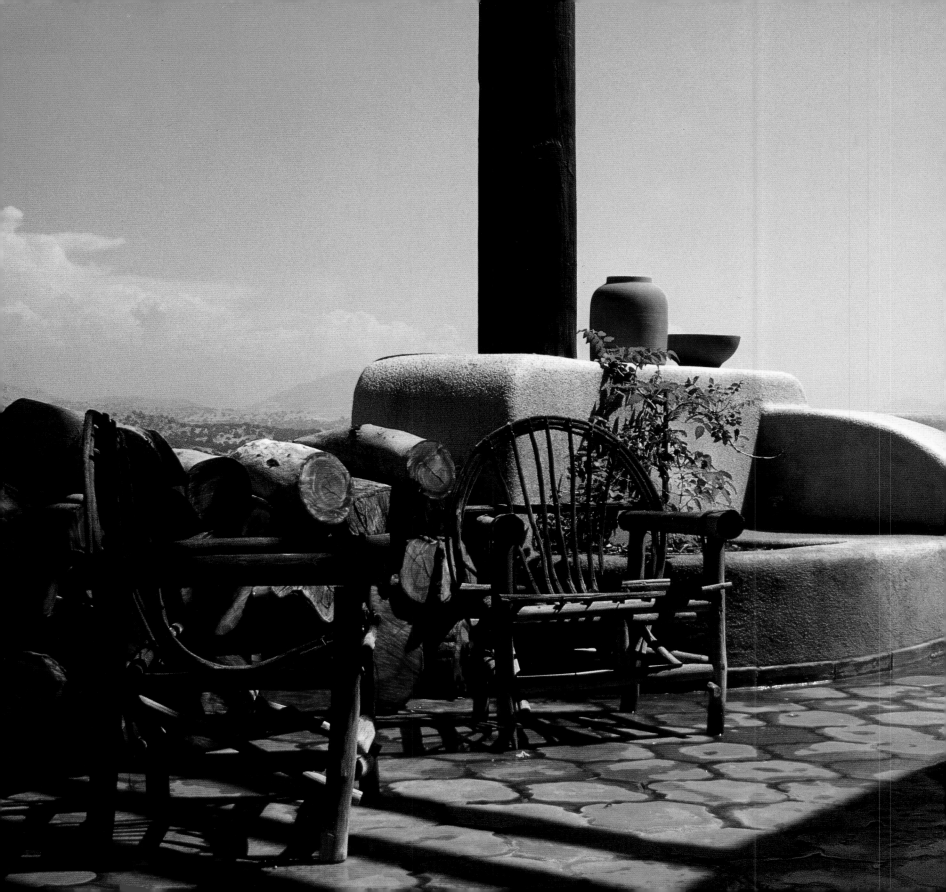

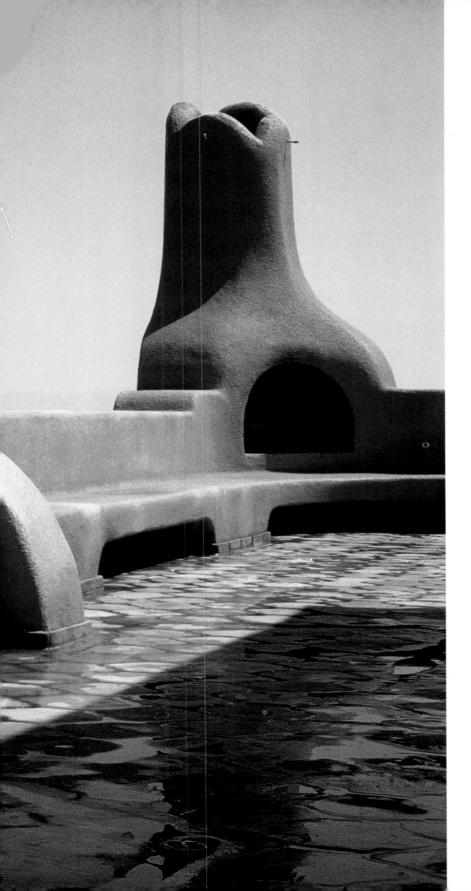

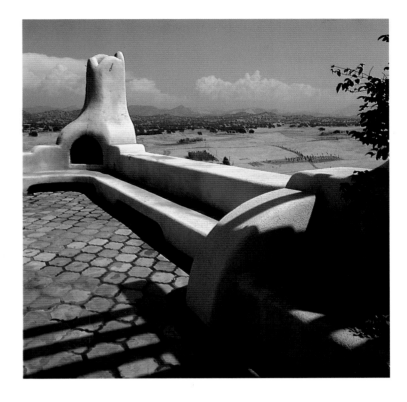

WILLIAM MINSCHEW In the foothills of California's Central Valley, internationally renowned sculptor William Minschew has carved himself a personal oasis. Aptly named Volterra —Italian for turned earth—it required Minschew to literally move earth and rock, transforming twenty acres of hilltop into an "artists compound" of extraordinary breadth of vision. His enviably large studio, with its commanding views of the surrounding valley and Sierra Nevada mountains beyond, extends out into tiled terraces walled in stucco, at two corners of which Minschew has incorporated fireplaces. The terraces are ideal for entertaining, and the fireplaces lend a grandeur or intimacy as needed, as well as providing an added inducement to enjoy the panoramic vistas on a chilly evening.

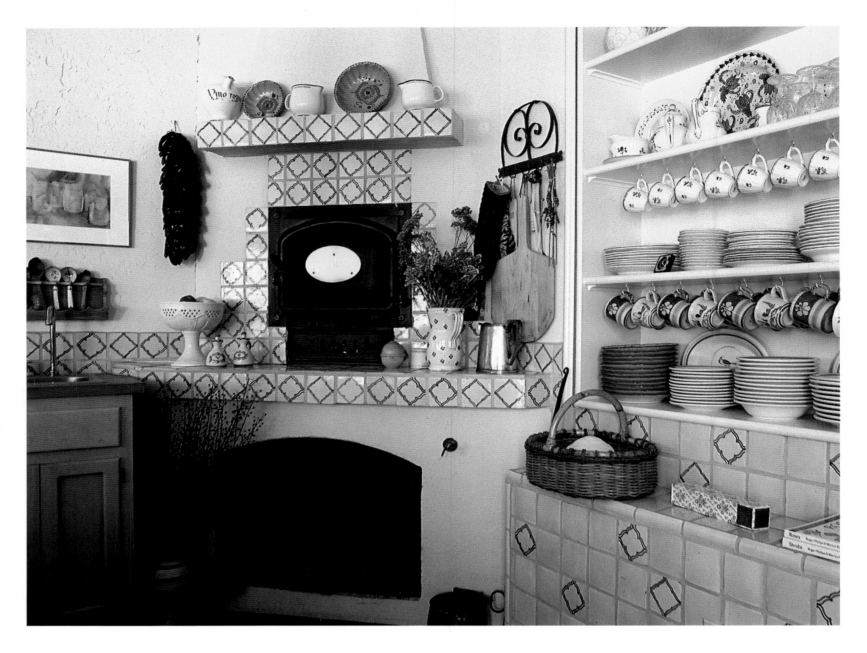

COUNTRY KITCHEN In constructing this inviting tiled oven, the owner was inspired by a restaurant in Madrid. The tile in this case is Mexican and was used throughout the kitchen. The oven is used regularly for baking bread and roasting small game.

This wooden mantelpiece in the kitchen of the same Rutherford, California house was in place when the owner moved in. The rustic carved mantel, the work of a local woodcarver, helps give character to a dining nook.

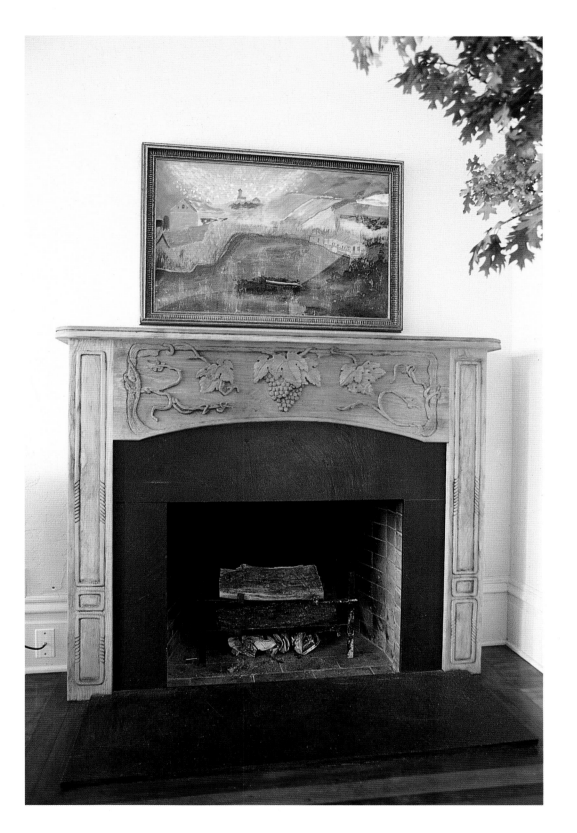

THE CONTEMPORARY FIREPLACE

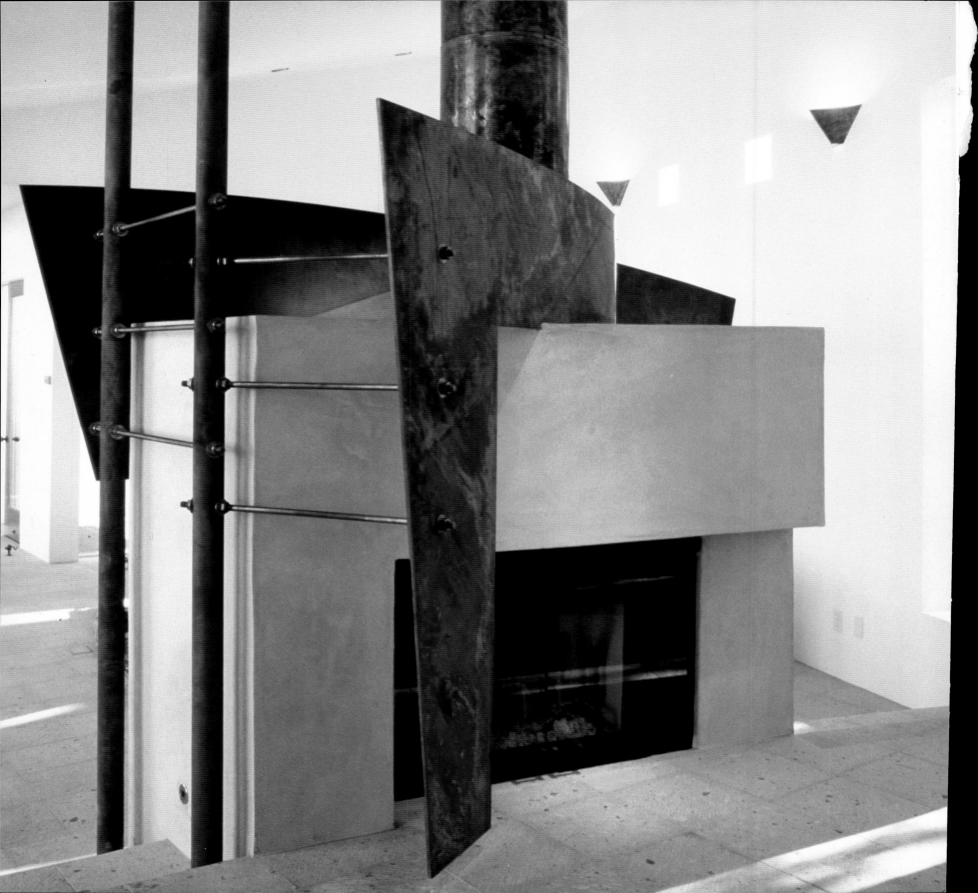

 By far the largest category in our book, the contemporary fireplace reflects the wide diversity of today's architecture. The contemporary fireplace borrows, adapts, and creates anew, employing a dazzling array of materials. A firesurround may stand out on its own; or it may be designed to blend with an overall architectural scheme, be it modernist, minimalist, postmodern, or eclectic.

You won't always find the contemporary fireplace where you might expect, either; you will see one at the top of a stairwell, freestanding in the middle of a room, occupying an entire wall, or spilling out into the room. You will find them raised to eye level at a foot of a bed, lowered into conversation pits, even double-fronted to serve two spaces.

As never before, designers, artists, and architects are paying attention to the fireplace and producing innovative and forceful designs. Some may see the hearth as an excuse to indulge their most creative side; others take a lighthearteded approach; still others see the fireplace as an icon and celebrate its symbolic value in our lives. Some designers are concerned with function; others purely with aesthetics (sometimes whether a fireplace even works properly can be a minor detail).

The fireplaces in the following pages are practical, fanciful, pared down and sleek, outrageous, or reverential. We were constantly surprised by the diversity and the sheer range of talent that we found.

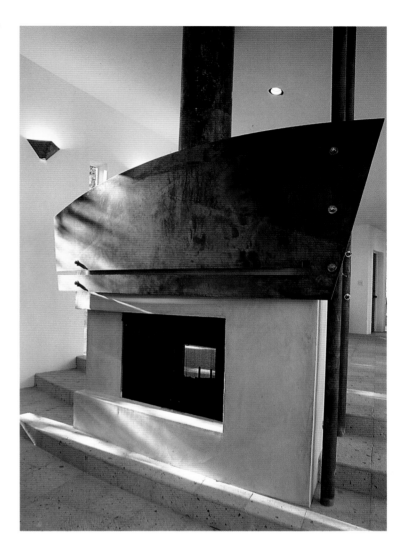

HOUSE + HOUSE This bold design by Mark English of the architectural team of House + House divides the dining room from the seating area in a newly renovated house in Hillsborough. A simple concrete box with a steel-troweled stucco surface housing a double-fronted firebox was mounted with large-scale pieces of carefully curved and sharply angled metal. The metal, crafted by Norman Petersen, was specially treated to achieve an aged-copper patina, on which shifting patterns of light play. The highly sculptural effect creates a sense of movement and interest.

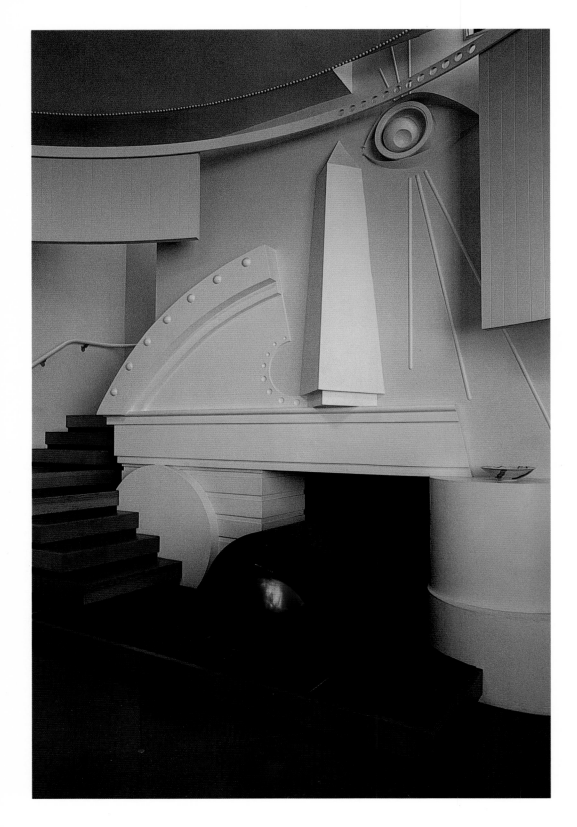

IRA KURLANDER

Architect Ira Kurlander drew inspiration from a "face fireplace" in a Palladian villa in devising the dramatic sculpted overmantel for his studio and home. "Something pretty strong was needed to counter the view," he explains, a view from high atop a hill in San Francisco that has been likened to that from an airship. He cleverly incorporated his Italian Mannerist–influenced design into a set of stairs whose lines echo the curved cornice. The wood-burning stove—imported from Vermont and set on a raised, slate-tiled hearth—will heat the entire house on a couple of buckets of wood.

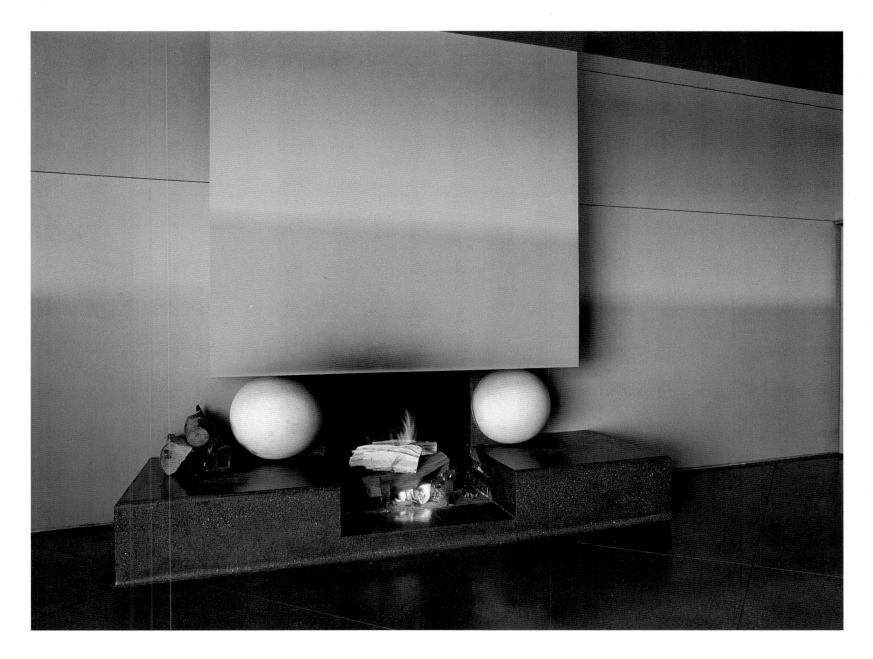

Artist Spaulding Taylor didn't want a
fireplace in the converted industrial
space he uses for a studio and home.
Architect and friend Ira Kurlander per-
suaded him that the main working and
living area needed a focus. Kurlander's
simple but dramatic design consists of a
large square header supported by two
stone spheres resting on a raised gran-
ite hearth.

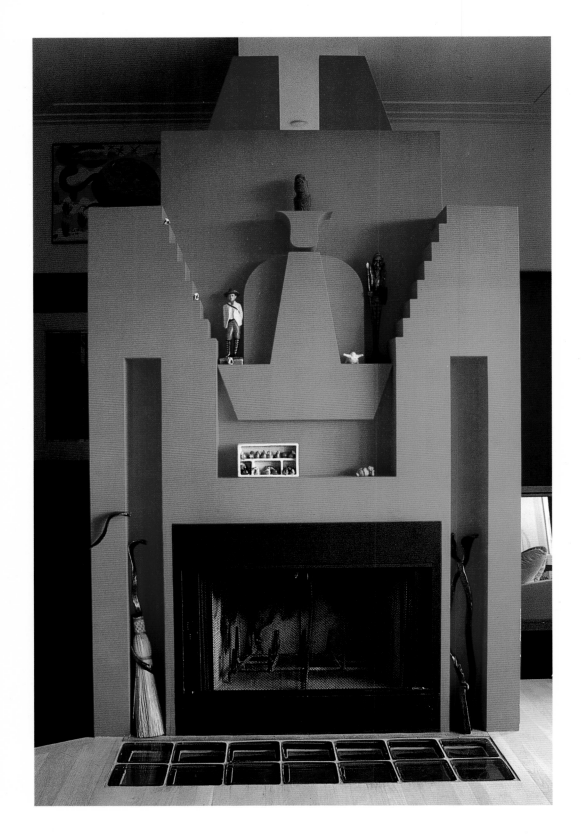

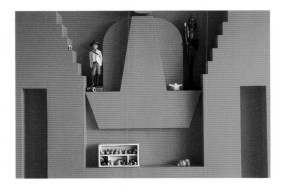

DAVID WEINGARTEN

Architect David Weingarten of the innovative firm of Ace Architects designed this intriguing fireplace for his former San Francisco home. It is set at the top of a stairwell with an unusual glass block hearth. Weingarten explains that the design was "Egyptian in inspiration" (note the cobra-shaped balustrade finial just visible to the left) "but through different lenses." The fireplace is actually housed in a wood cabinet painted a rich orange red.

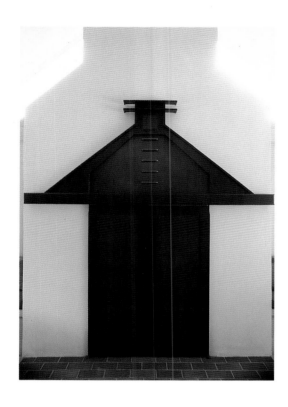

TAD CODY

This handsome and unusual stainless steel fireplace is the work of Tad Cody, of the Palo Alto architectural firm Cody & Associates. Its lines find echo in the greater contours of the building and more immediately in the shaping of the chimney. The hinged doors were inspired by the steel shutters found on windows in California's Gold Country; the firebox is a Rumford design. Cody employs steel in many applications, and here he has painted the fire surround in two shades of green used elsewhere in the building, giving the metal a softer, more elegant finish.

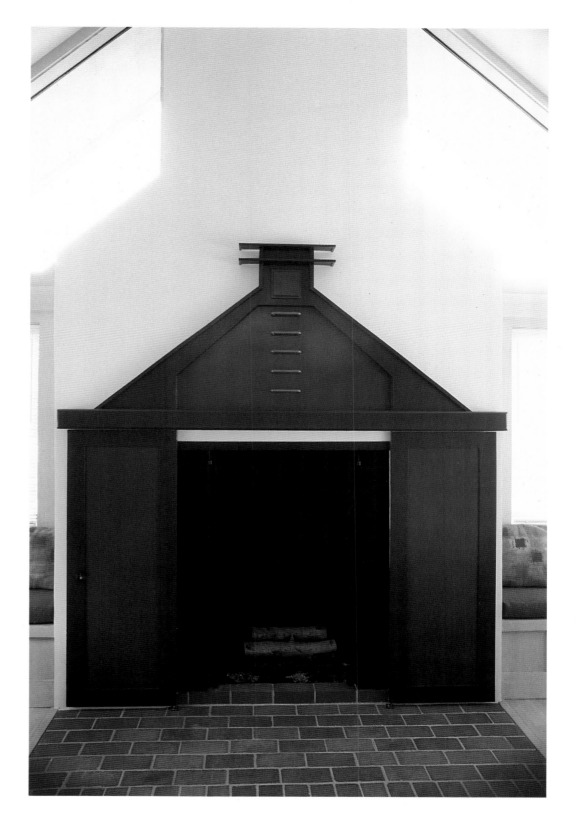

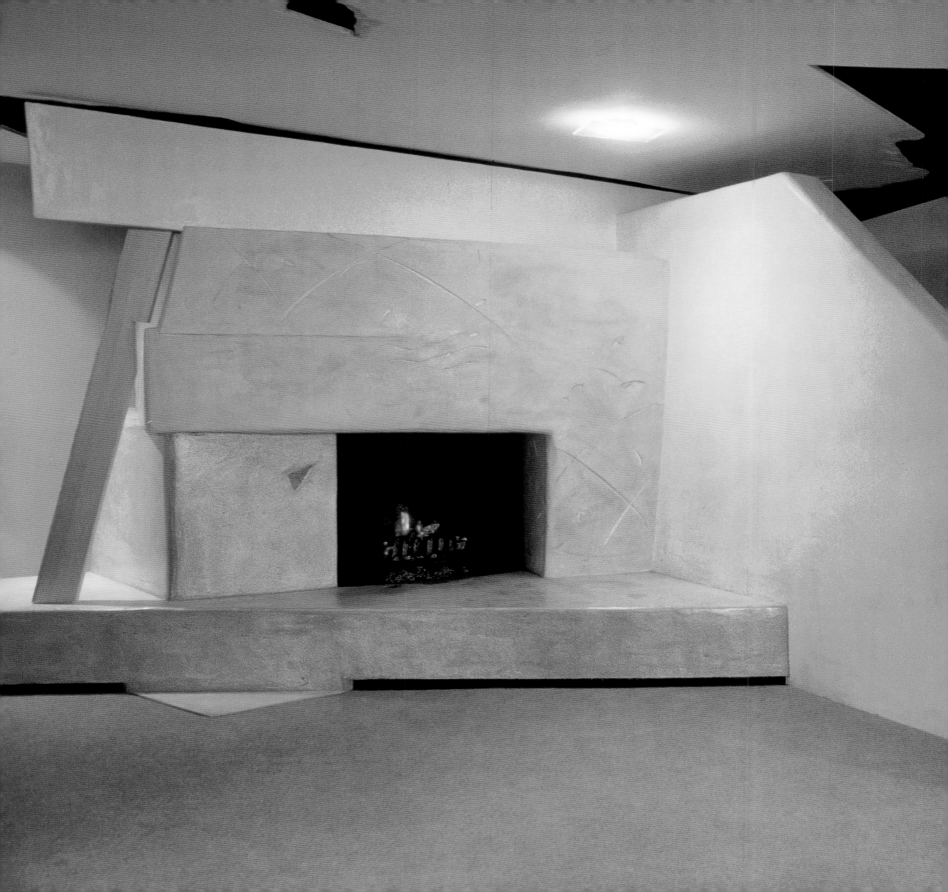

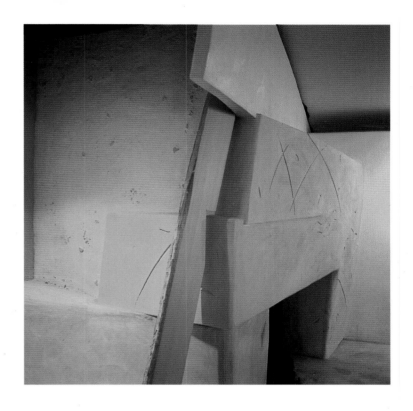

FUTUNG CHENG In a dramatic solution to a downstairs room, architect Futung Cheng painted the ceiling black and constructed a rough-hewn "cloudscape" that seems to hover over the equally dramatic fireplace, softening its sharply angled lines. The fireplace itself, designed by Cheng and executed by Darell Bidstrup of Redefining the Hearth, is a series of plaster forms, sculpted on site and placed on an elevated, elongated triangle of a hearth. The asymmetrical play of angles, carried over into the adjoining wall, gives a nice sense of movement to this striking fireplace.

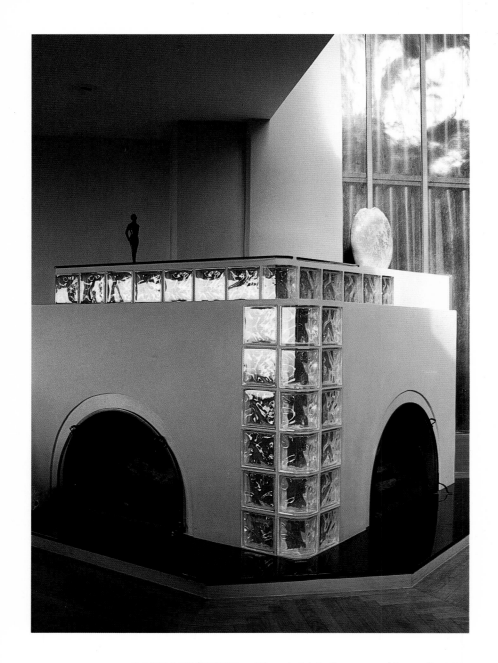

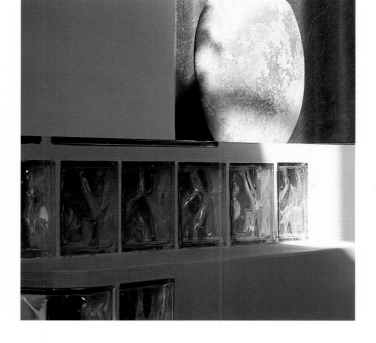

DARELL BIDSTRUP Glass brick is the unusual ingredient in this double-fronted fireplace serving an open-plan dining and living area in a home high in the Berkeley hills. Darell Bidstrup came up with the design using the glass for added interest and play of light.

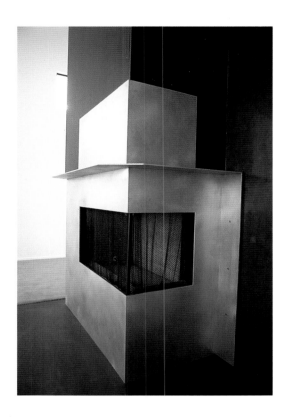

FREDERICK FISHER

In an upstairs bedroom of a Marina Del Rey house, architect Frederick Fisher set a prefabricated firebox, open on one corner, into a section of built-out wall. The firebox was then clad in burnished aluminum. Fisher, with his fine arts background, works with collages of disparate colors and materials, establishing here a complex play of planes of color (pigmented plaster has been used on the walls), light, and material.

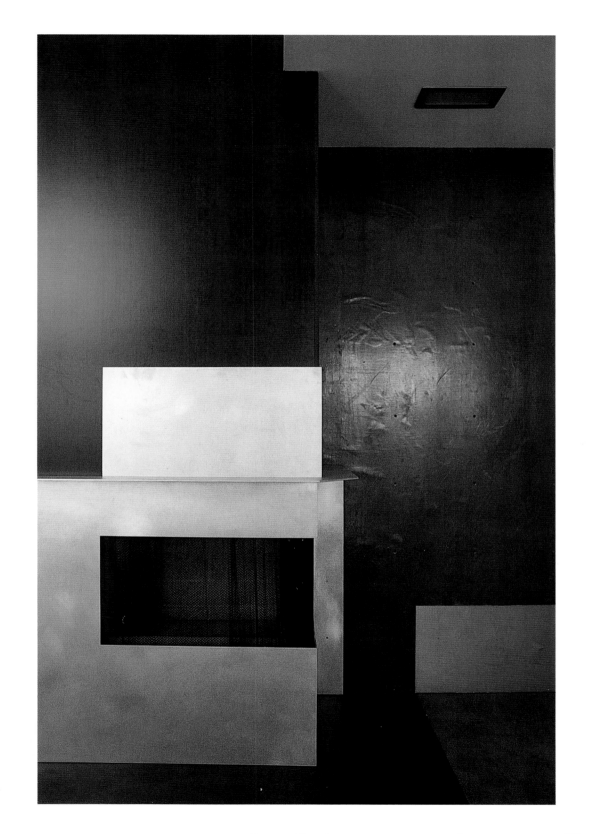

ROBERT HUTCHINSON

The softly molded forms of this unusual fireplace were designed by Robert Hutchinson to echo the staircase with its pantaloon-like festoons. A large niche on the left is for logs, and a smaller one on the other side is for kindling.

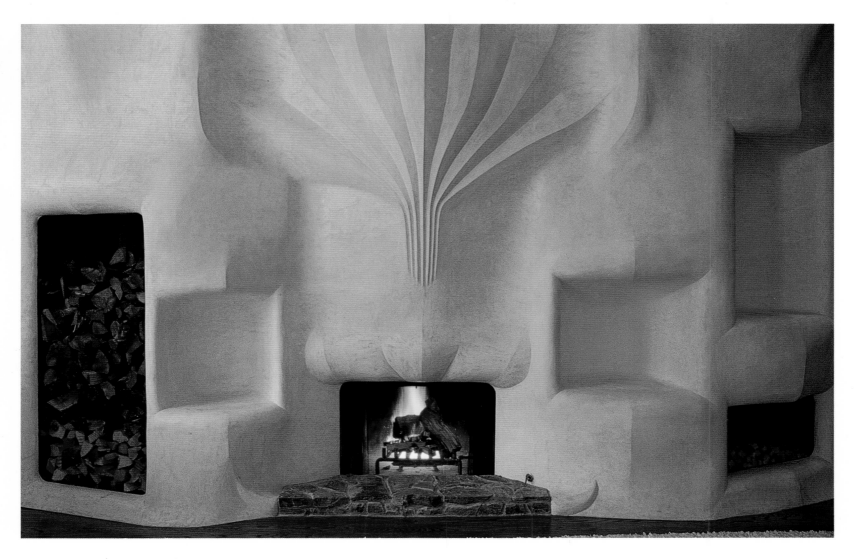

BEEBE/YUDELL

Tina Beebe and Buzz Yudell from the innovative Los Angeles architectural firm of Moore, Ruble & Yudell chose a simple, yet pleasing, form for the double-fronted fireplace in their home. It is flanked by steps leading from the living room to the dining room. The firebox, with its Italian limestone hearth, is a Rumford design chosen in part because Beebe and Yudell like the proportions.

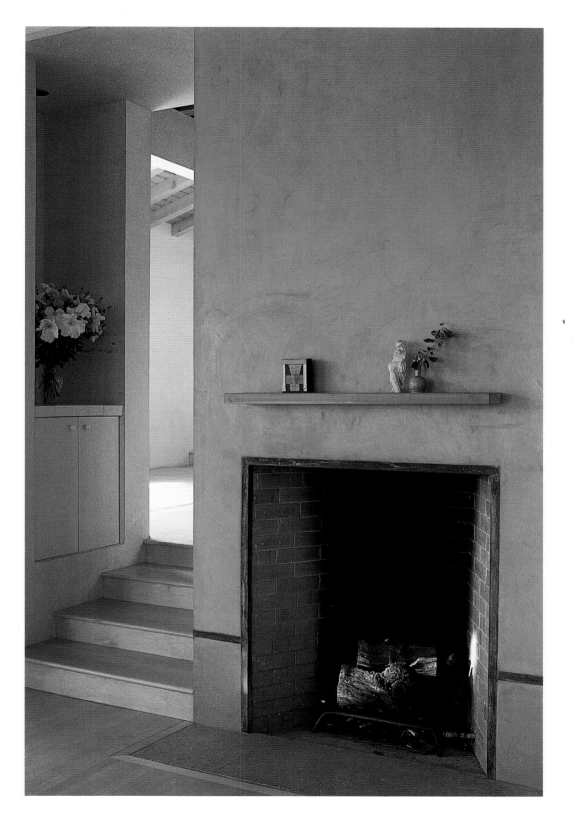

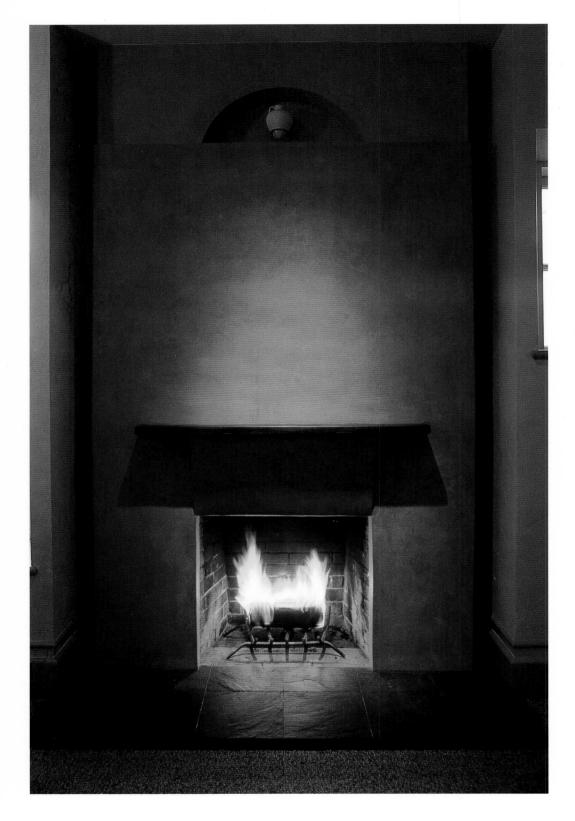

KAREN ADELSON

Interior designer Karen Adelson readily admits that this striking fireplace in her teenage son's room is a direct copy of a Michael Graves design. "I love the purity of the neoclassic lines," she says, adding that it took a lot of mixing to get exactly the warm terra-cotta tone she wanted. It was built for her by Darell Bidstrup, who refaced the pre-existing brick-and-stone version. Despite referring to it as "Mum's Egyptian room," Adelson's son clearly approves.

FREDERICK FISHER

Using concrete block, enlivened with an infusion of color and texture, Los Angeles architect Frederick Fisher has fashioned a fireplace of sturdy proportions for a contemporary house in the Marina Del Rey district. The fireplace continues a wall treatment that intersects the interior planes from the exterior.

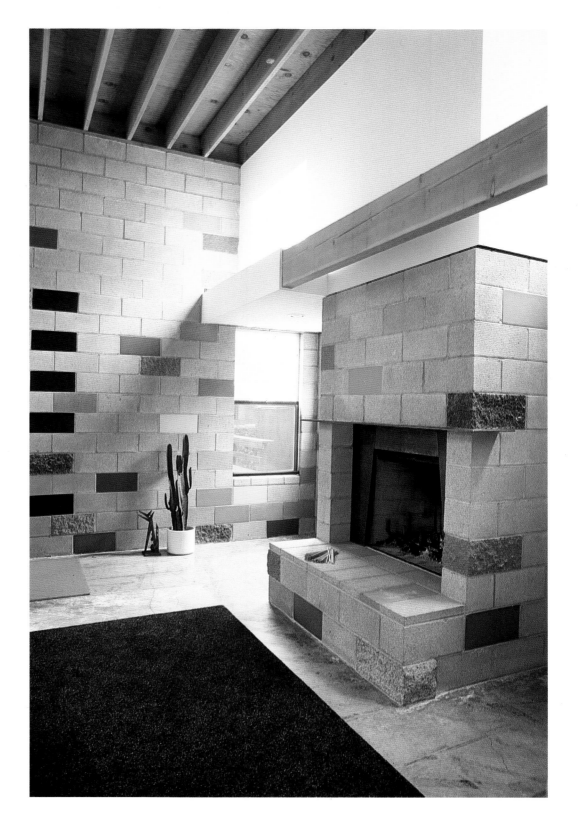

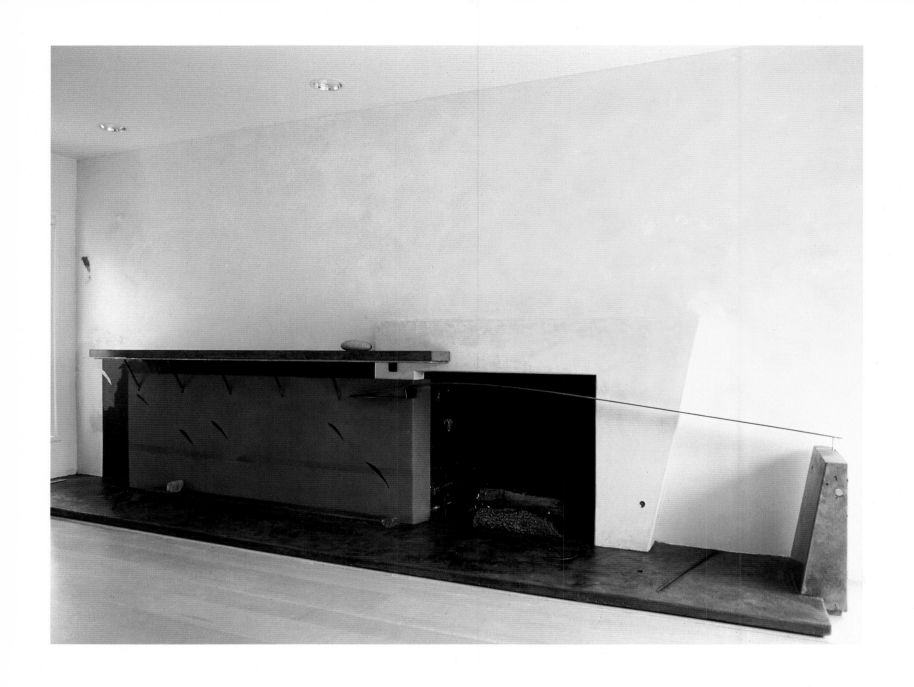

FUTUNG CHENG

Using color-integral cement and steel, architect Futung Cheng has crafted a wall-sized, highly sculptural firesurround in a recently remodeled home in the Berkeley hills. Cheng set up a play of different textures and finishes as well as fixed and seemingly free-floating forms. The treatment of the cement produced a subtle sheen, and the steel was either rusted and given a finish coat or specially burnished and bent. Cheng included his trademark stone and two fossilized shells which he embedded in the hearth and jamb.

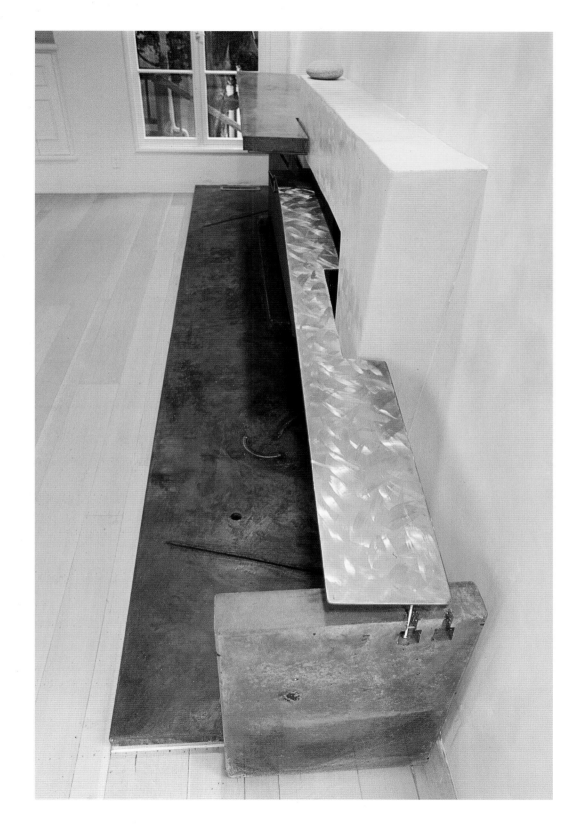

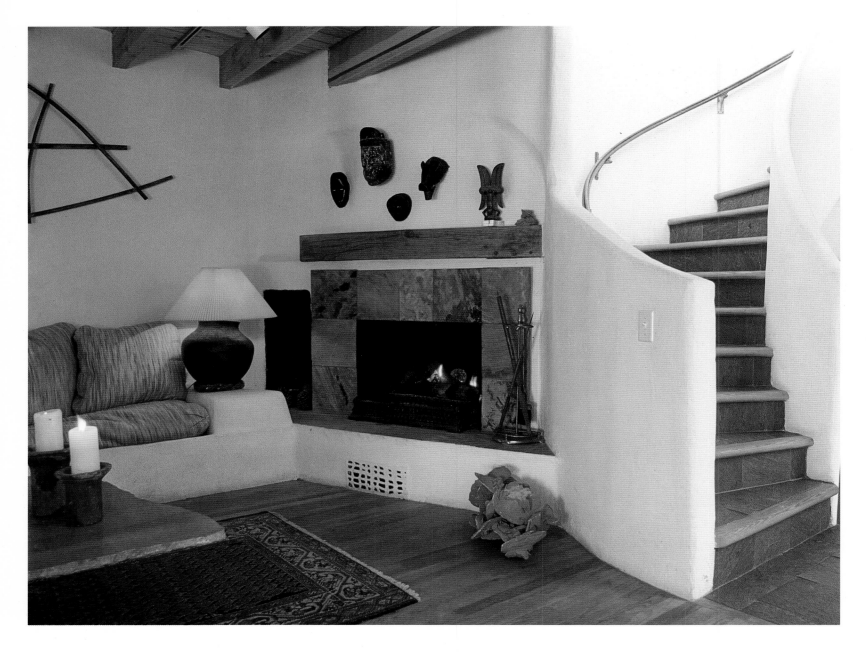

JAMES & GILLIAN SERVAIS For their own living room, James and Gillian Servais chose a simple fire-surround in African slate with winged jambs to cover heating vents. The mantel is a piece of Limousin oak James found in a fireplace shop. The grill beneath the hearth is a ceramic design.

In the living room of a house built by the design team of James & Gillian Servais, the fireplace has been positioned to make it part of the focal point: an impressive view. Two colors of sandstone were used, hand selected by the Servaises from an Arizona quarry. "We craned in the pieces from the street," says James, who goes on to explain that the design for his fireplaces evolves from a hands-on manipulation of the materials rather than from a master drawing. "The ratio and dimensions are extremely important," he adds: "sometimes what looks good in a drawing just won't work." The copper strip picks up a motif used throughout the house where copper is seen in the form of railings, sconces, and on doors.

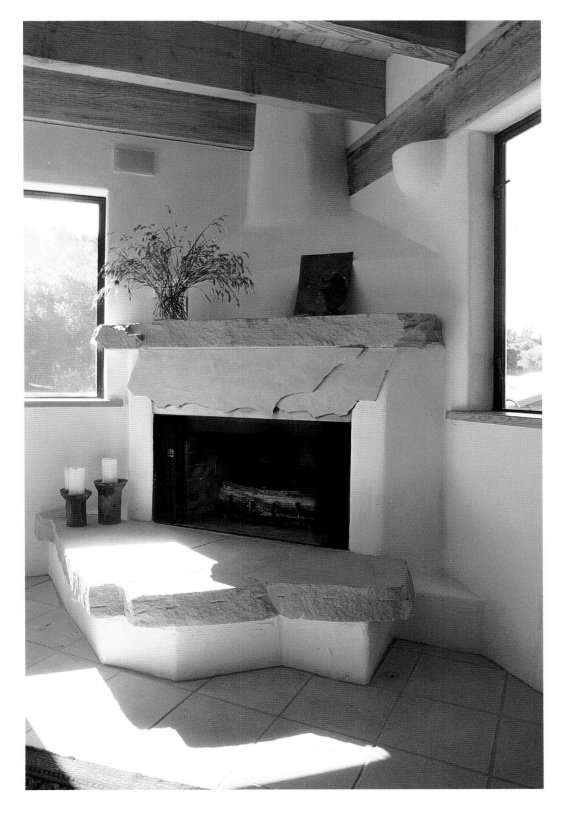

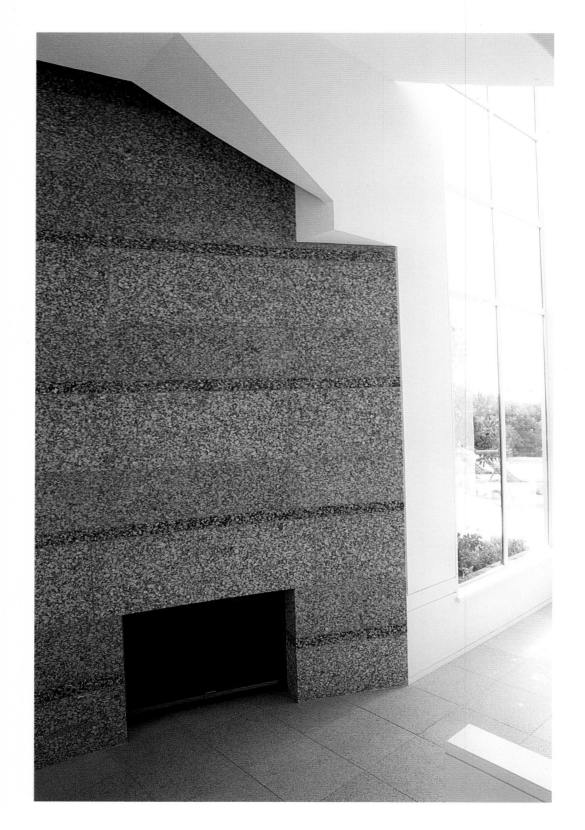

CHARLES MOORE

An impressive elliptical wall of granite houses a sunken fireplace in this Malibu villa built by Charles Moore with Urban Innovations Group associates Robert Flock and Robbin Hayne. The granite bands of Rockville white and beige imported from Italy, gives it a pinkish blush and provides the only touch of color in the otherwise all-white house. The built-in seating facing the fireplace forms an area of intimacy and softness in this light-filled beachfront home, with its generous windows and interior courtyard.

ROBERTO VARRIALE

Architects Debbie Chung and Joseph Chance found the two side molds for this stylishly simple and functional fireplace design in stone caster Roberto Varriale's studio and had the artist make a matching hearth and mantel. As part of an extensive remodel of their San Francisco flat, Chung and Chance built out the wall in the living area to accommodate a slightly deeper firebox. The substantial hearth anchors the jambs and mantel.

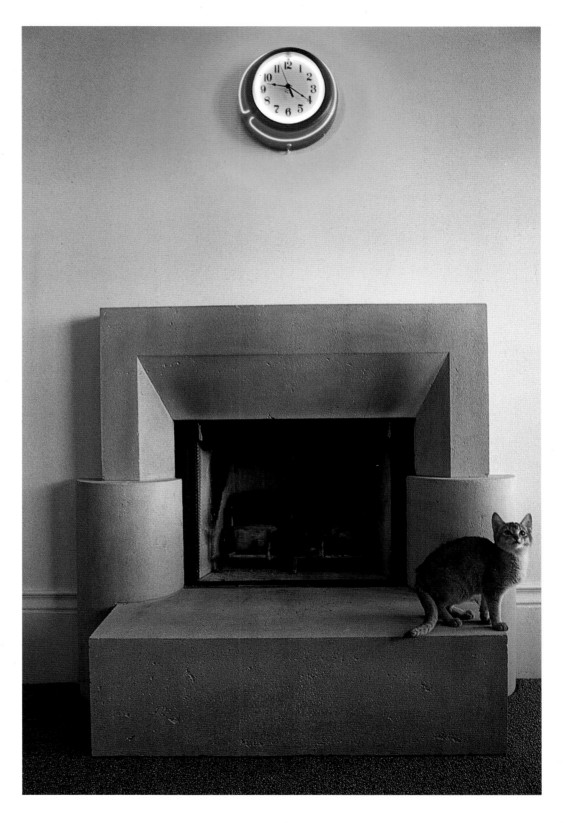

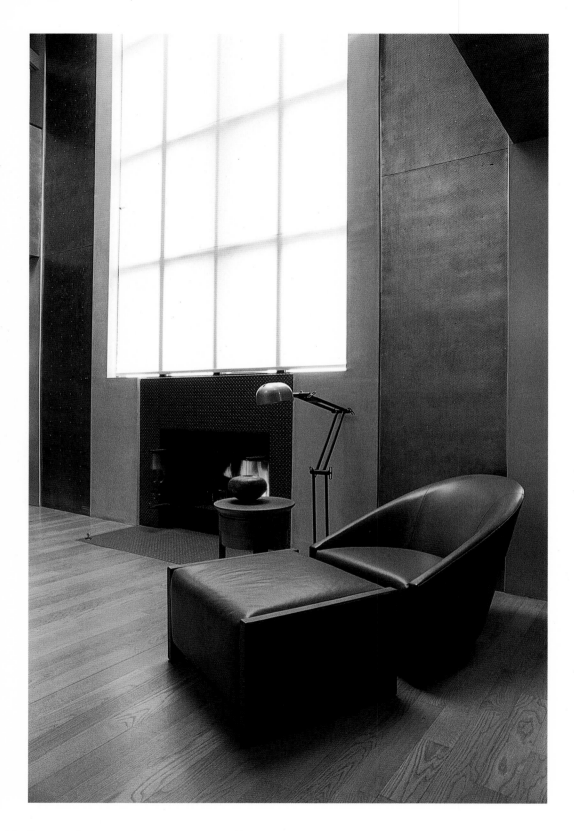

DANIEL SOLOMON

This highly contemporary home, complete with two studios, belongs to Pat Gleeson (who writes movie scores) and Joan Jeanrenaud (who is a member of the Kronos Quartet). Architect Daniel Solomon unifies the two sections of a large open-plan living area by centering a fireplace under a window. Solomon gives a prefabricated firebox a simple metal frame, echoing the innovative punched-metal panels added to the walls, which in the sun take on a burnished look and give the interior a warm, intimate feel. The relatively modest proportions of the firesurround are in keeping with the low horizontal lines of the furnishings and their warm beige and charcoal tones. The chair is by Stanley Jay Friedman and the articulated lamp by Artemide.

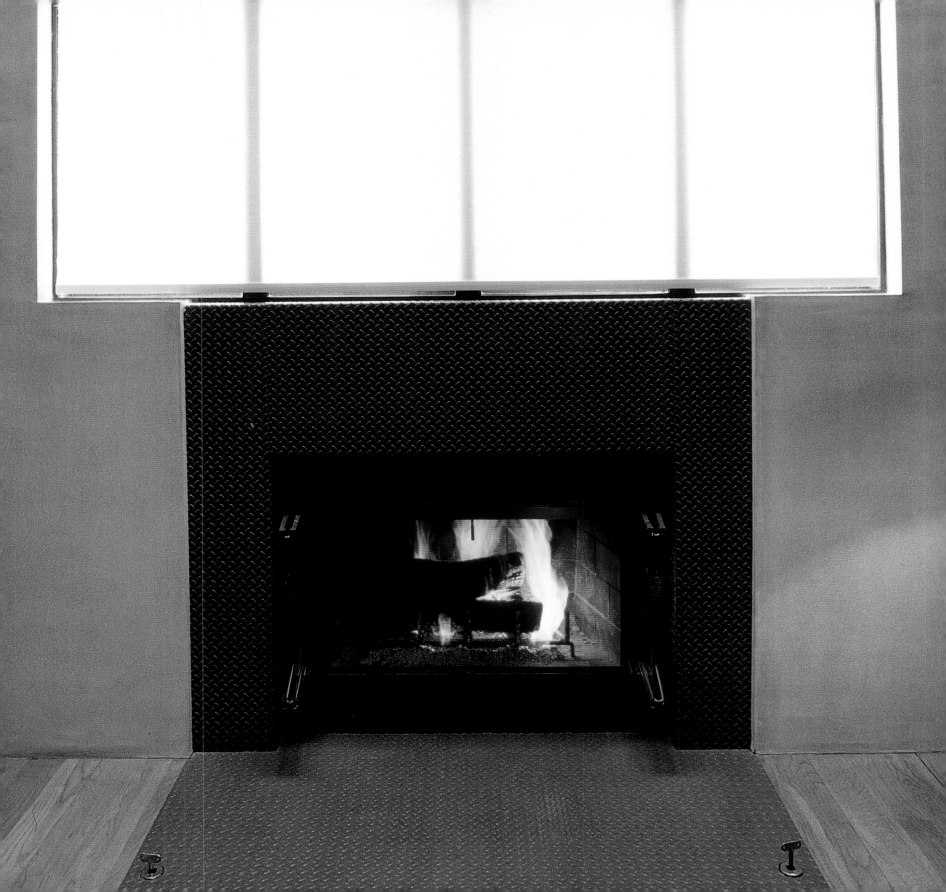

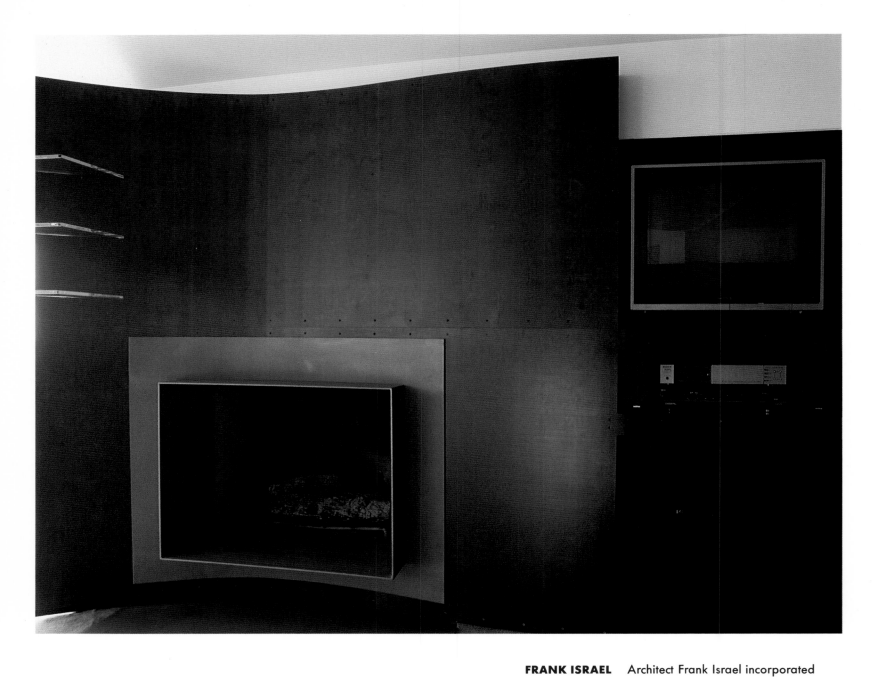

FRANK ISRAEL Architect Frank Israel incorporated a media center into a seemingly free-floating wall housing a sand-blasted steel surround firebox in the bedroom of a Los Angeles home. The subtly undulating curve of the wall, thinly colored plywood, adds a sense of movement and lightness.

TOBY LEVY

In a remodel of a former ranch-style home, architect Toby Levy relieved an existing fireplace of its boxy wood and brown tile surround and gave it a sculptural and contemporary new look. The wall housing the firebox was built out and the firesurround and chimney breast clad in thin-gauge steel finished by hand, used in other elements throughout the house. A recessed light was placed in a narrow, elongated niche in the chimney breast.

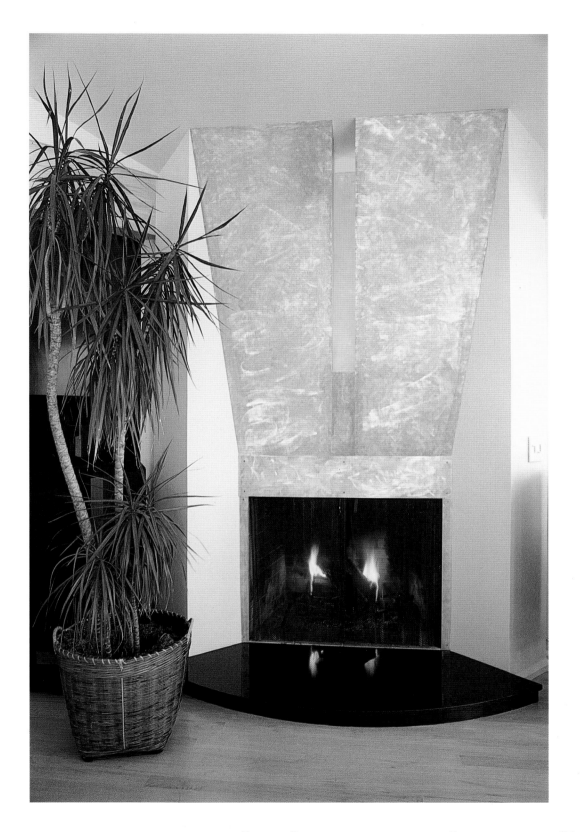

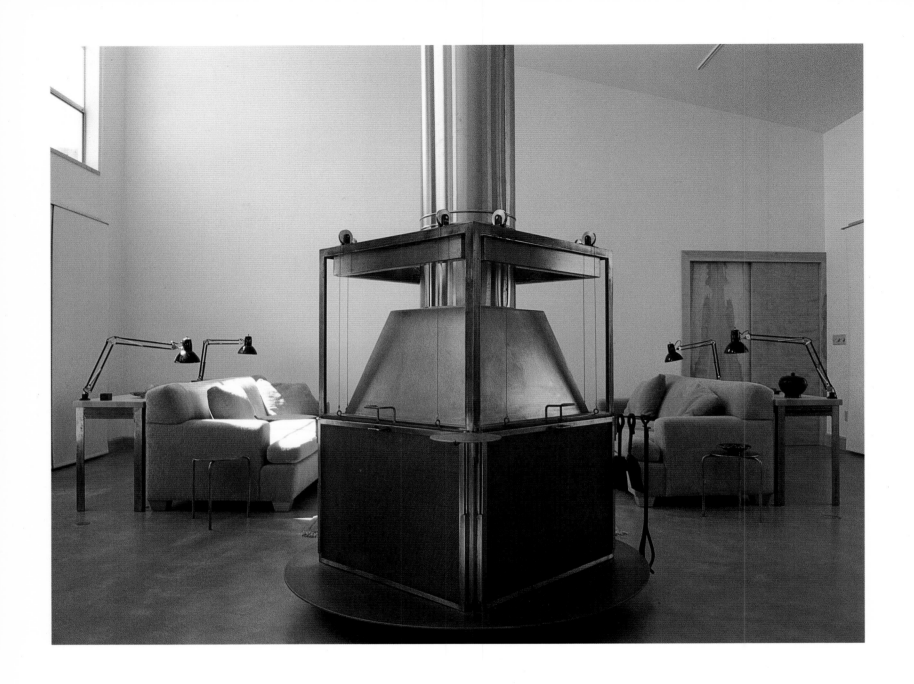

CORDELL/MORTON

When New York architects Tom Cordell and David Morton bought property deep in the country north of San Francisco, they decided to raze the existing buildings and build two combination living and work quarters facing each other across a hundred-foot-square courtyard. Morton and Cordell have made extensive use of materials such as corrugated galvanized steel, birch, and concrete, chosen for their utility and economy. For the light-filled, high-ceilinged living quarters they designed a free-standing metal stove on a circular dais hearth with four counter-weighted doors. To execute the design, the architects commissioned Malm of Santa Rosa and are quick to praise the particularly skilled welding of fabricator Leon Myers.

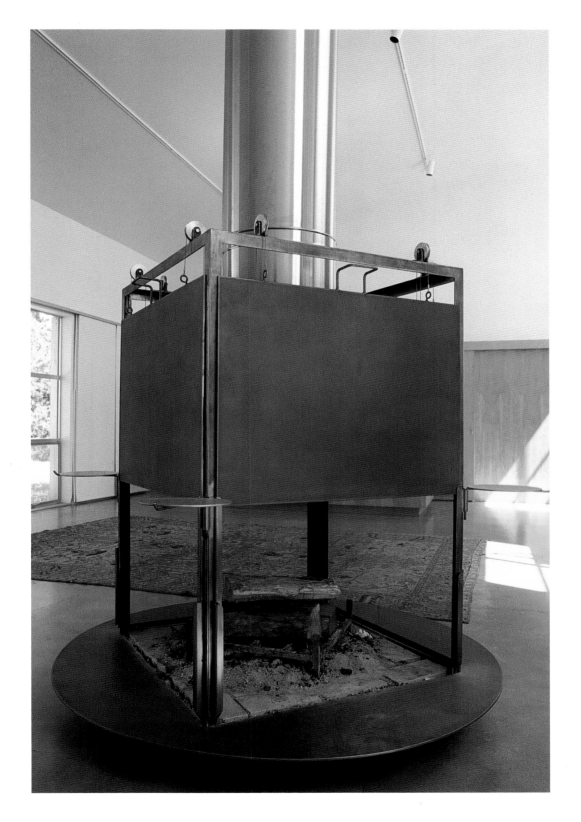

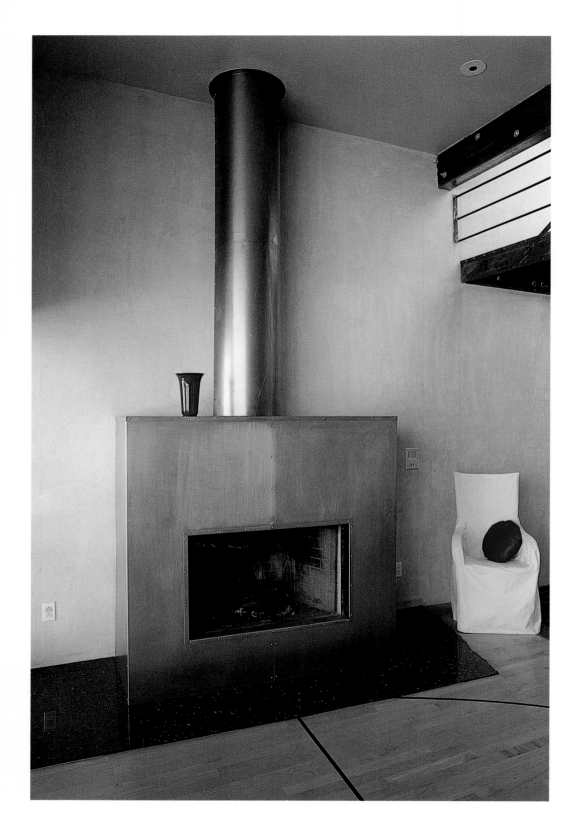

MICHAEL HARRIS

Clad in cold-rolled steel, this fireplace anchors its living room corner in the home of architect Michael Harris and Becca Foster, owner of a lighting studio. Its design is sufficiently bold to counterbalance a large bay window with a commanding view of San Francisco and the East Bay. Standing on a black granite hearth that extends laterally, the rigorously ordered lines of the fireplace are a reflection of Harris's design scheme, which blends European and Asian aesthetics. (Harris studied and worked with Japanese architect Fumihigo Maki.) The house is imbued with an elegant simplicity, much of which comes from the choice and integrity of materials and from an underlying complex organizational structure.

JERRY BROWN

Increased awareness of the need to conserve fuel and a concern for heat efficiency and practicality have led to a modest comeback of stoves, and there is a wide range of design styles available. This perky example, which looks like an espresso machine, is in the home of former California governor Jerry Brown.

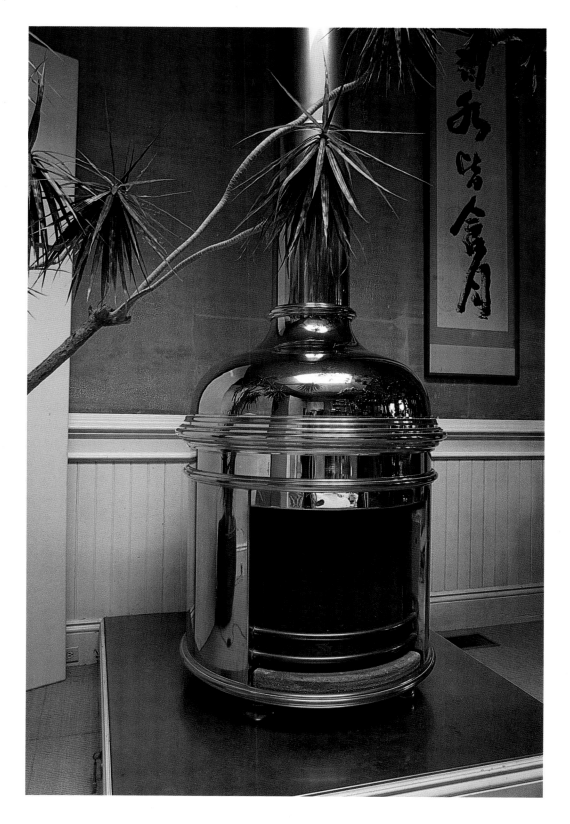

ART AND ARTIFICE

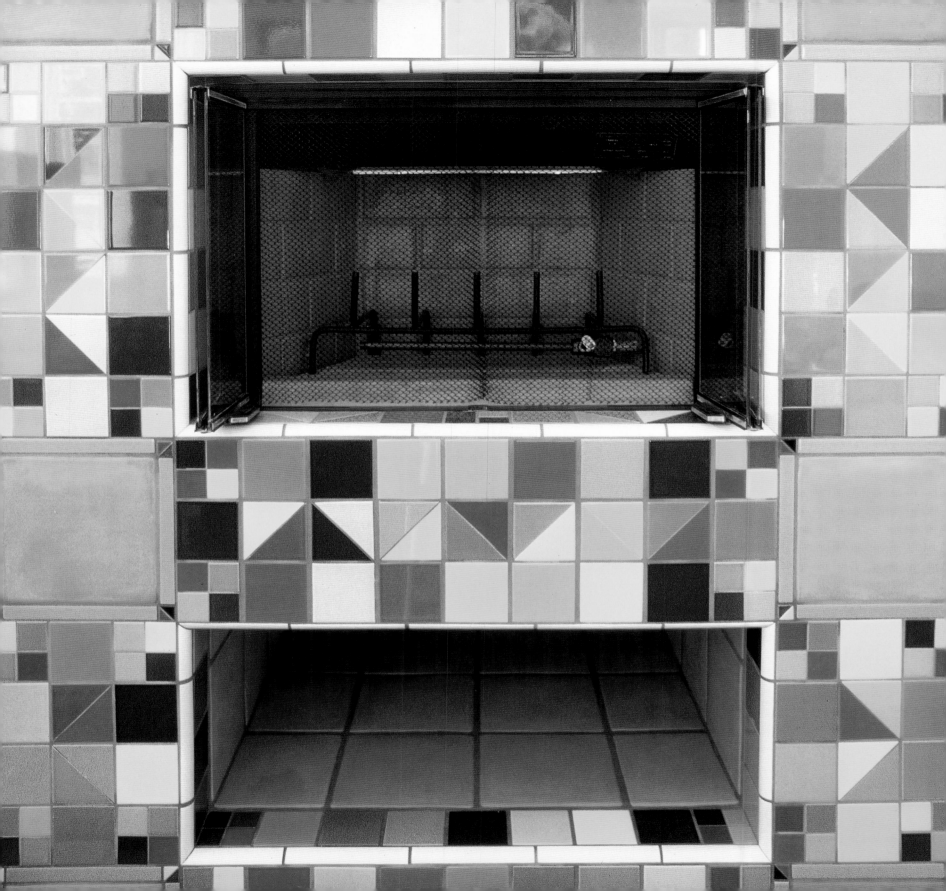

In this chapter, we have selected examples of fireplaces that exhibit a marked imagination and flair setting them apart from the commonplace. Some show what can be done with a skillful application of painterly techniques, whether to effect a total transformation of a nondescript firesurround, to create a statement, or to blend more closely with the style of a particular interior. In others, color is boldly exploited in surprising splashes of primary hues, or in subtle faux treatments.

Many artists are lending their talents to the hearth often using the firebox as simply an excuse to create an artwork. One fires individual tiles to frame a firebox, another sculpts steel and wood to form a striking freeform mantelpiece. Other examples have been singled out—one for a firesurround that displays a sense of playfulness and character with the humblest of tools and props; others for their unexpected juxtapositions: rustling cans alongside roses, broken tiles set in plaster, the antique married to the modern.

Perhaps the element common to all these fireplaces is a sense of fun, of not being hampered by any limitations. If all you have is a dull fireplace, begging to be disguised or awkwardly situated, don't despair, let the following sampling be proof of the possibilities.

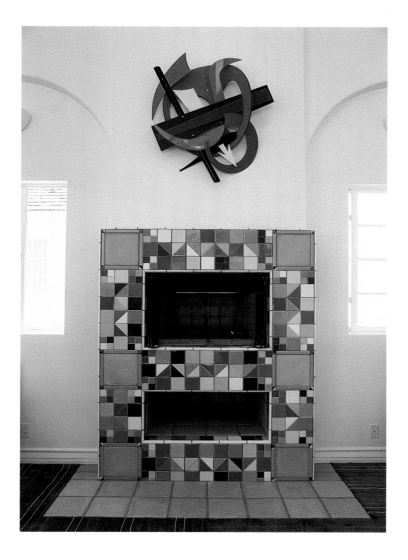

VAN-MARTIN ROWE In a newly constructed 1930s Spanish-style home in Santa Monica, designer Van-Martin Rowe was given a free hand to design a fireplace in the master bedroom. Rowe, who professes to use materials as if working on a collage, used thirty-two different colors of Italian tile for the firesurround. He also raised the firebox so that the fire can be visible from the bed, adding a niche for firewood underneath. The owners, inspired by the brilliant color scheme, found a metal sculpture by San Diego artist Norman Ridenour, a perfect match for the tile.

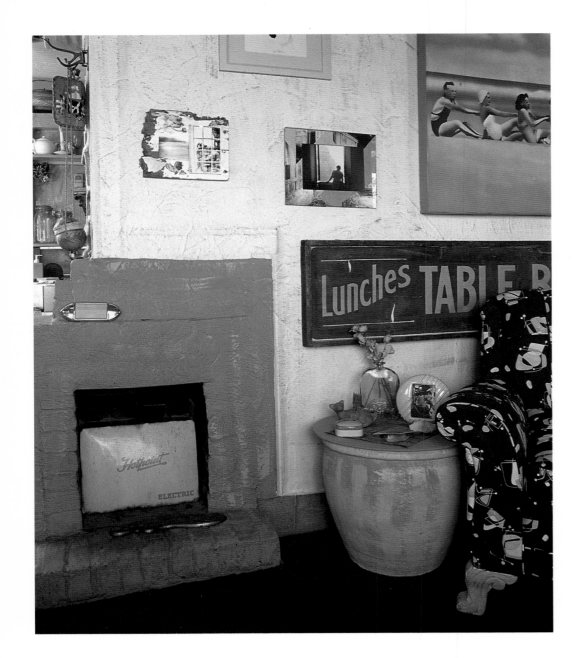

SHAWN HALL Instead of trying to disguise the awkwardly placed corner fireplace in the cottage's living room, Hall has given it a coat of paint in blue and purplish hues, which she continues along the skirting board. With typical wit she has chosen to fill the firebox mouth with the door from an old Hotpoint stove.

Designer Shawn Hall lives in a tiny cottage—what used to be two dormitory rooms for dock workers—perched on the Filbert steps on San Francisco's Telegraph Hill. In a bedroom, Hall, who loves to make use of flea market finds for her work, covered the brick surround of a nondescript corner fireplace with Arizona flagstone and topped it with a mantel of birch wood. She has hung the walls above and alongside with what she refers to as "mostly junk": a piece of a wrought-iron railing, rusting cans, and bric-a-brac, among which she has placed some roses. The clever juxtaposition of objets trouvés gives this corner immediate interest.

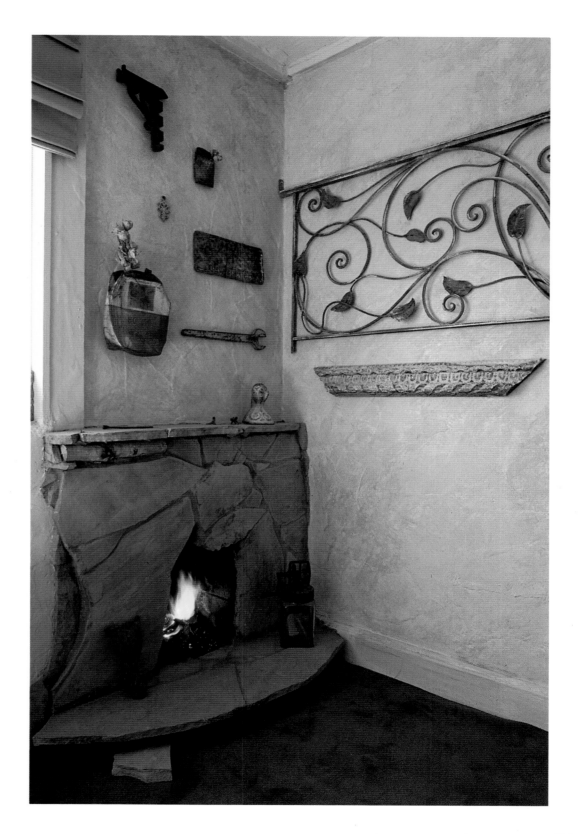

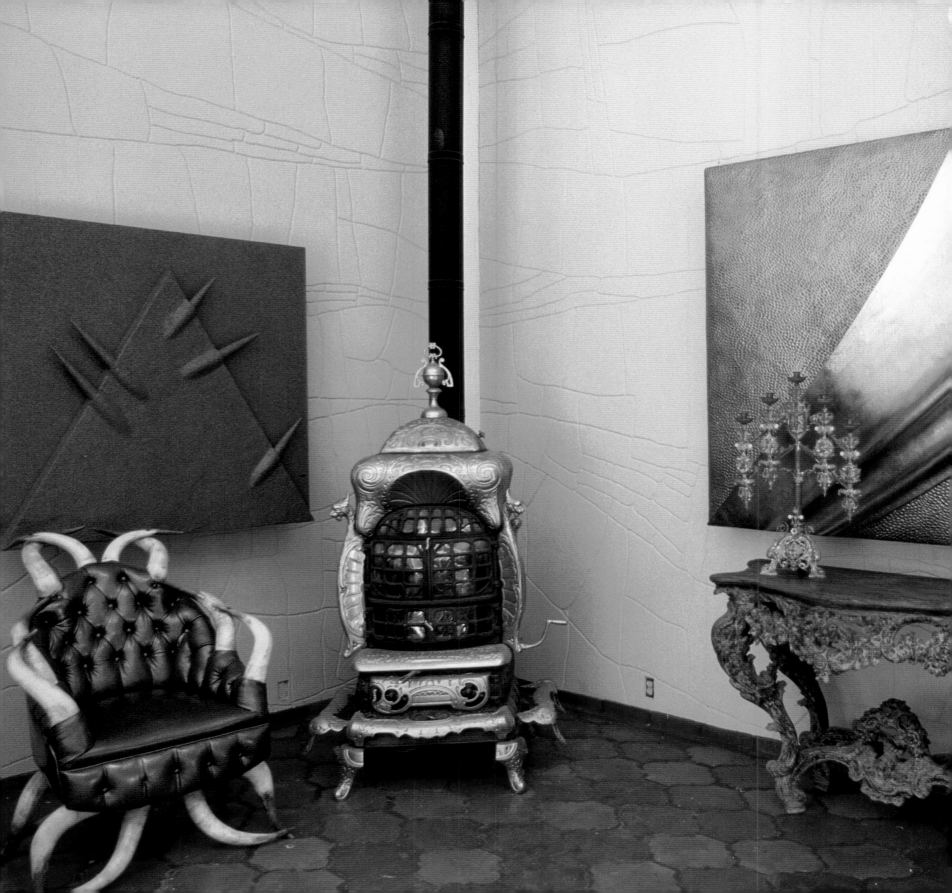

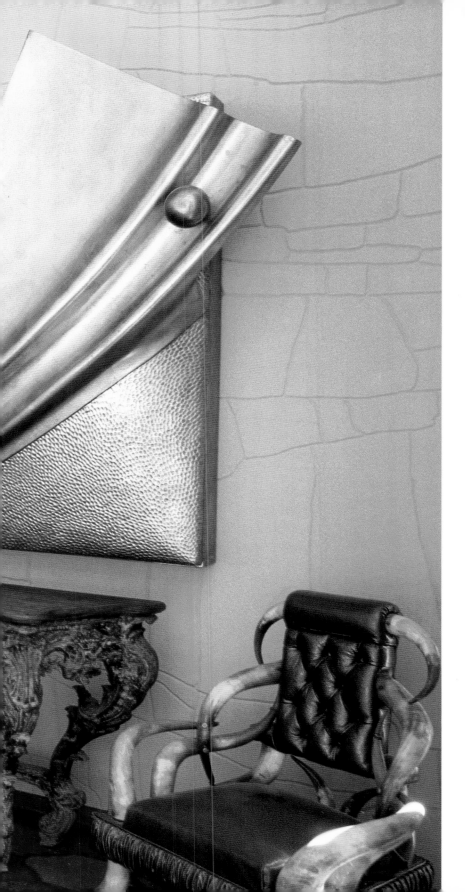

WILLIAM MINSCHEW Sculptor William Minschew searched for years before finding this prize 1875 nickel-plated Victorian wood-burning stove, culled from a cabin in Nebraska. It sits comfortably at home in its gothic glory among the marble and bronze sculptures in the artist's studio, accompanied by a Baroque Spanish console table and a horn-and-leather chair, part of a set given by actor Gary Cooper to a friend and bought by their present owner at auction.

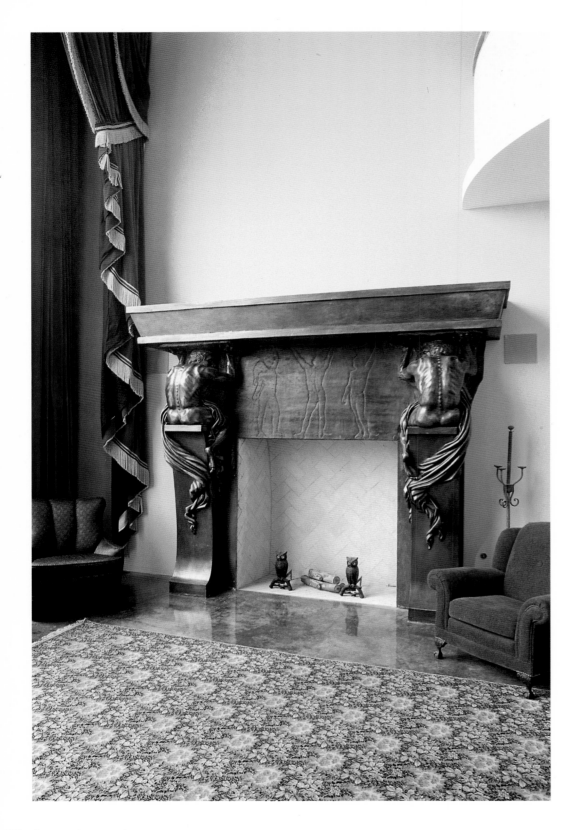

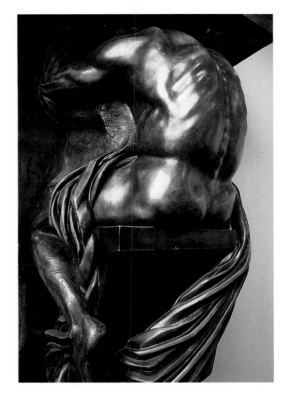

ARTHUR/HOSCH

No one entering this faux Victorian-fronted house can be prepared for the interior. Its living room was conceived of as the stalls of a theater, with stage curtains pulling back from double-story glass double doors and window to reveal a poolscape and Los Angeles beyond as a stage setting. The owner of this strikingly original home is Scotsman Ian Arthur, proprietor of a lighting store. Arthur commissioned Michael Hosch to design a fireplace, fittingly grandiose in concept, employing crouching Atlantes figures. Hosch incorporated the life-size figures into the jambs of the suitably commanding mantelpiece, burnishing it with graphite powder that was then waxed.

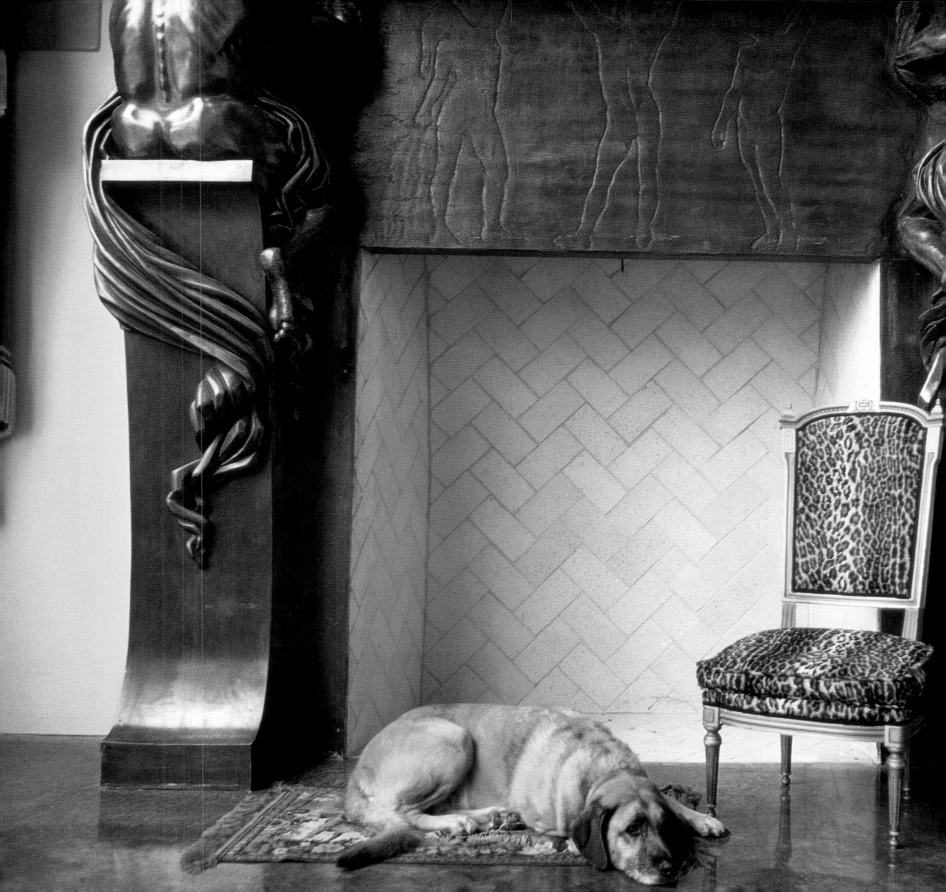

KAREN THOMPSON

The owner of this fireplace, set in an awkwardly shaped, small-scale living room, originally wanted a study in white but, encouraged by artist Karen Thompson, agreed to a bolder design, consisting of a serpentine hearth in mosiac tile inset with marbles, a motif she repeated for the mantel, including its underside. She topped it with a large mirror, picking up the colors of the mantel and adding warmer, richer tones.

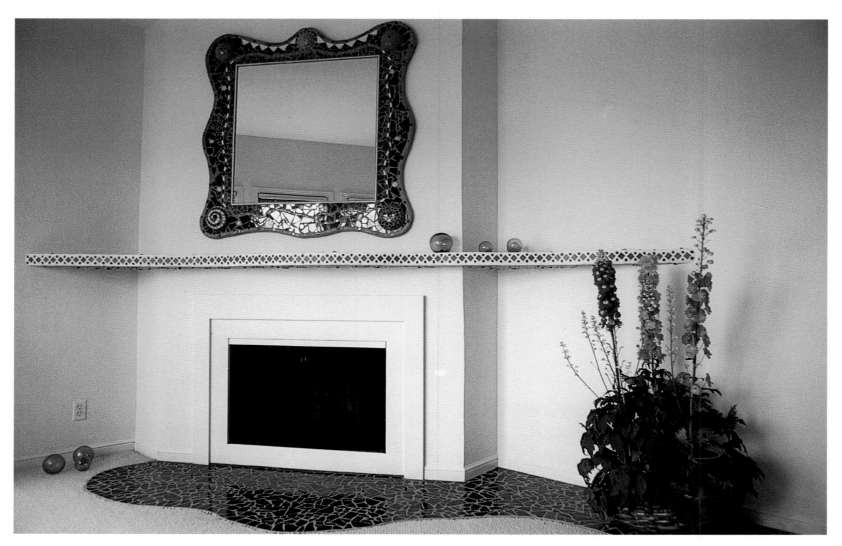

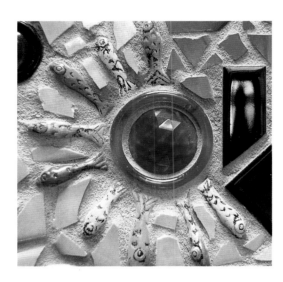

Artist Karen Thompson and former partner Barbara Matthews devised a highly original mosaic hearth—a "flying carpet"—with matching mirror for a converted loft space in the home of former gallery owner Carla Baird. They set in concrete ceramic pieces, broken watch faces, glass, and other objects in an array of vivid colors, and added a laminated finish. The owner commissioned Susanne Wibroe to design a wrought-iron fire screen. Wibroe also furnished the metal sculpture that acts as a weight for a roof ladder pulley inconveniently located next to the fireplace.

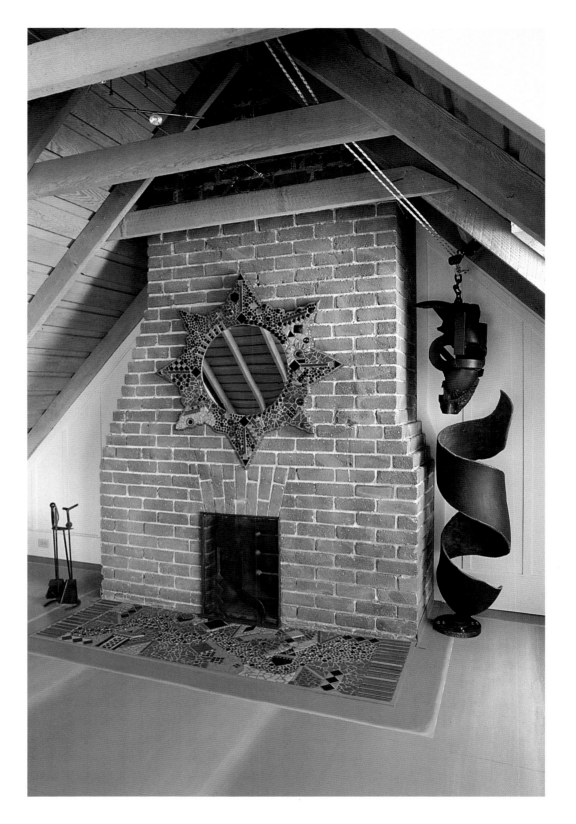

LAUREL LICHTEN-STUTSMAN In a 1920s "typical Venice Beach house," special effects artist Laurel Lichten-Stutsman applied her skills to the existing uninspiring brick fireplace. Using marbleizing and gold leaf, Laurel has transformed the surface into a display of color and originality.

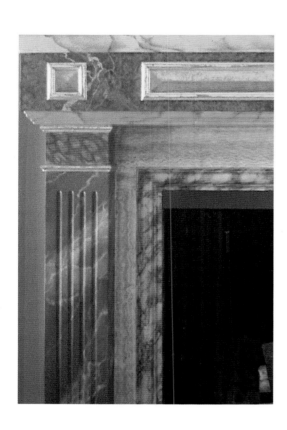

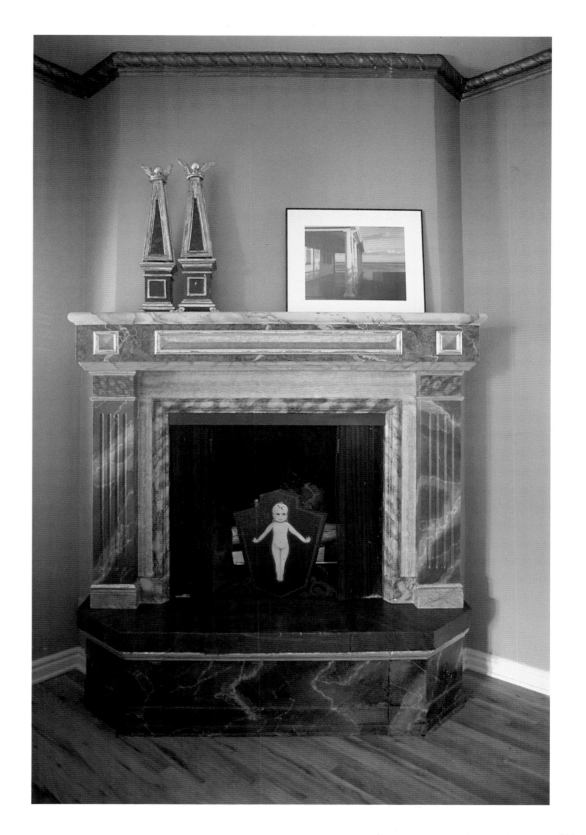

RON MYERS

In a house with interiors by designer Ron Myers, painter Steve Shriver gave a corner fireplace a sumptuous *faux* treatment with a palette to match the richly eclectic range of the room's furnishings. The painted figure on wood, reminiscent of Victorian dummy boards, is actually an objet trouvé.

BRIAN MURPHY

Los Angeles architect Brian Murphy of BAM Construction/Design likes to use materials out of their usual context. For the mantelpiece in his Santa Monica canyon home, he employed a simple formula of broken terra-cotta tiles set in plaster. The deliberately rough plaster finish, resembling frosting against the dark walls, coexists happily with the wrought-iron shelving above it. For a hearth, Murphy used an arrangement of black-and-white tiles, adding yet another unexpected touch.

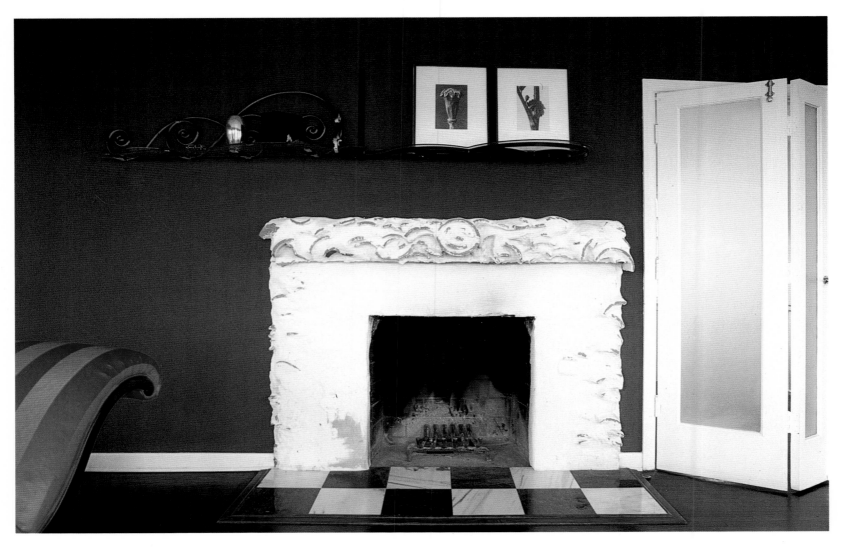

DALLA VALLE

Winery owner Gustav Dalla Valle and his Japanese wife, Naoko, wanted a rustic farmhouse for their Napa vineyard. Dalla Valle, who grew up on a family winery in Northern Italy and who has decided views on design, hired architect Gary Hansen to build a house that would integrate elements of his European heritage with a contemporary sensibility. The fireplace in the living room is Dalla Valle's own work, reflecting the blending of the Old World with the new seen throughout the house. Implementing his fine arts background, he framed the firebox with tiles from a fourteenth-century villa in the Veneto set onto a raised irregular stone slab hearth. The stone, which enhances the rustic feel of the fireplace, was found in a Sonoma quarry.

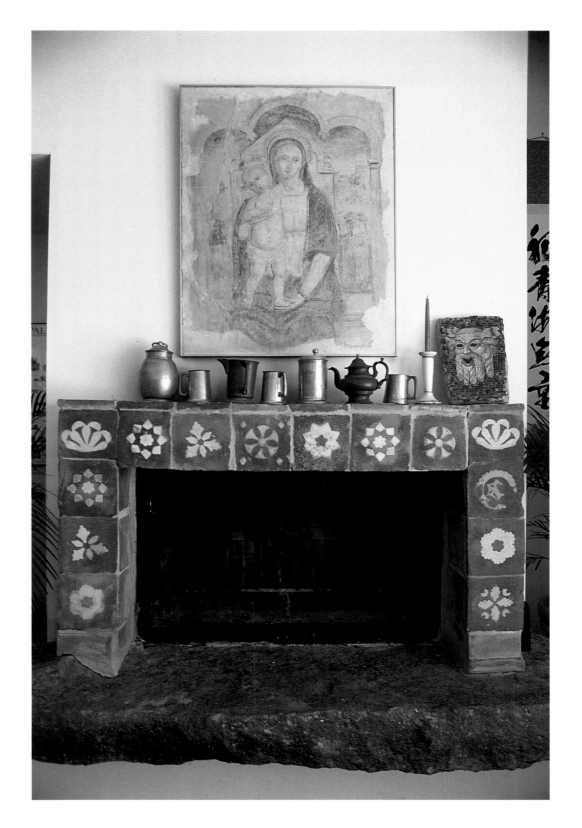

ROBERT HUTCHINSON In this extraordinary, cavelike dining room, designer Robert Hutchinson has integrated a fireplace into an organic design devised to showcase the owner's collection of antique olive oil jars. The designer saw the niches, including the firebox, as "negative cavities within the space," and sought to counter this "negativity" with the uniquely constructed dining table made from solid wooden shapes carved as if cut from the cavities.

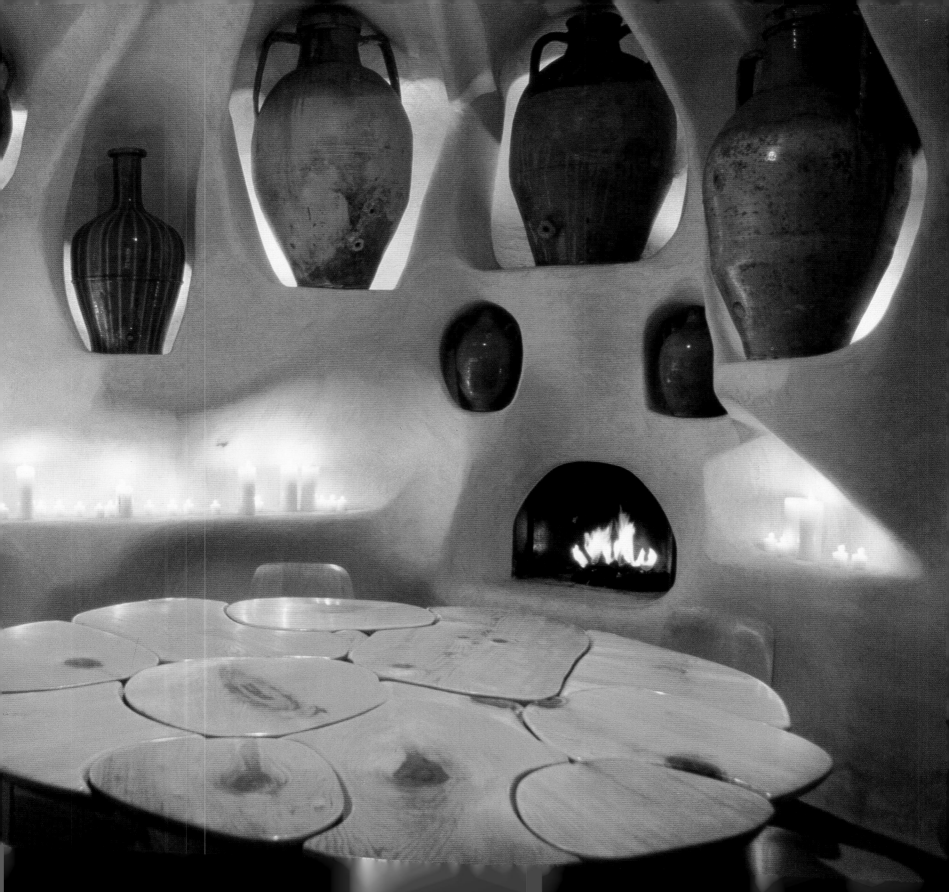

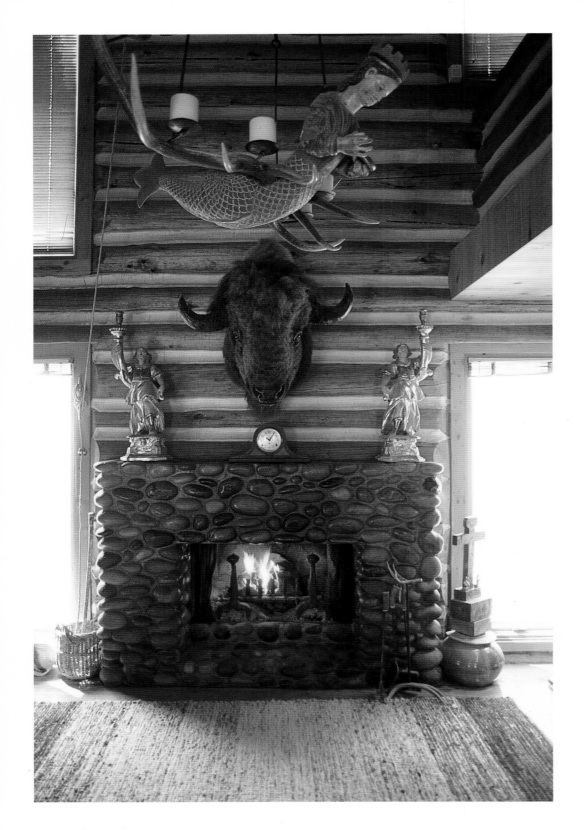

WILLIAM MINSCHEW

In keeping with the pioneer flavor of his log cabin temporary home, sculptor William Minschew built a hearth of fieldstone with an assistant, coating the stones, once assembled, with wax. The dimensions of the fireplace are small enough not to overpower the intimate living room, and large enough not to be overpowered in turn by the large buffalo head looming benignly over-head. The candle holders are from Verona, found while the artist was living in Italy. The hybrid candelabra came from a dealer who knew instantly that it would appeal to Minschew.

DANIEL J B-H LIEBERMANN

In a house in the Berkeley hills, designed by architect Daniel J B-H Liebermann and built by the owners, roughly cut stone from three quarries was used to construct three fireplaces on different levels. Liebermann placed the largest fireplace, which heats the whole house, in the kitchen area (right). The stone extends on either side of the fireplace along the elliptical wall of the room. Liebermann, whose work has a Wrightian quality, favors an "organic" approach, evident here and in the small living room hearth (above).

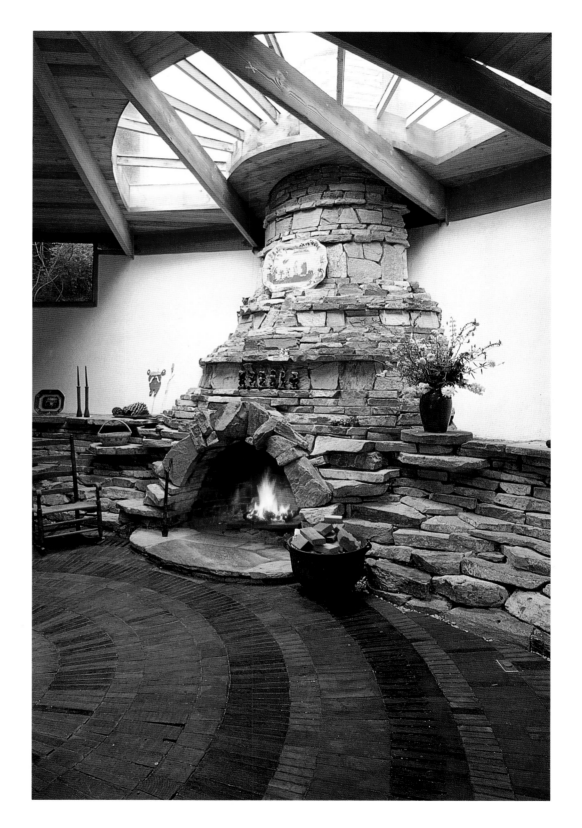

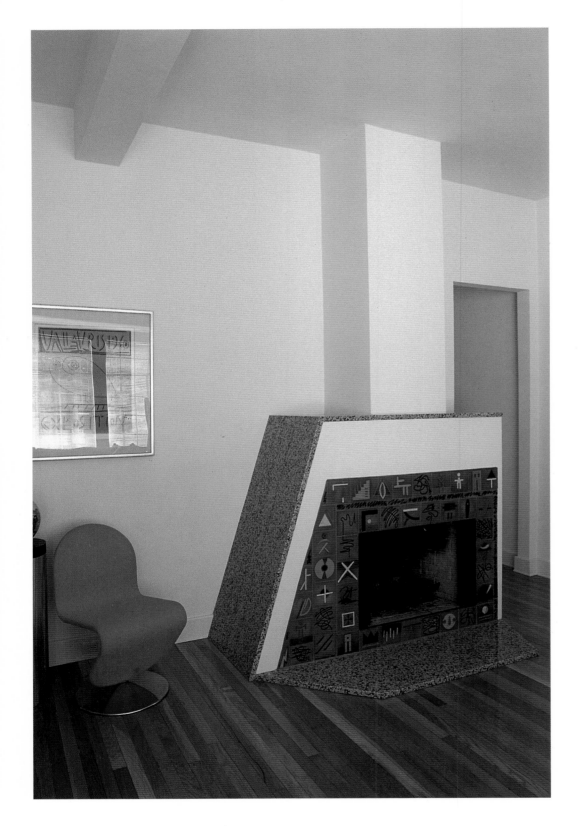

CHODKO/VON MULLER

In working out various possible configurations for the fireplace that jutted awkwardly out from a wall in this remodeled San Francisco Victorian home, former owner Erik von Muller found unlikely inspiration in a piece of cardboard casually leaned against a wall, and used a similar slant for the shape of the fireplace. He then covered the outer casing of the fireplace with granite that he also used for the asymmetrical hearth. Von Muller, an enthusiastic collector of modern art, commissioned local artist Dana Chodko to design a ceramic tile surround in warm earth tones, enlivened by whimsical patterns—an artwork in itself.

JO WILDER

This unusual mantelpiece, framing a simple fire surround, is crafted from sculpted burnished steel and wood. Owner Jo Wilder's collection of African antelope heads, set on spindly legs, make a fitting addition.

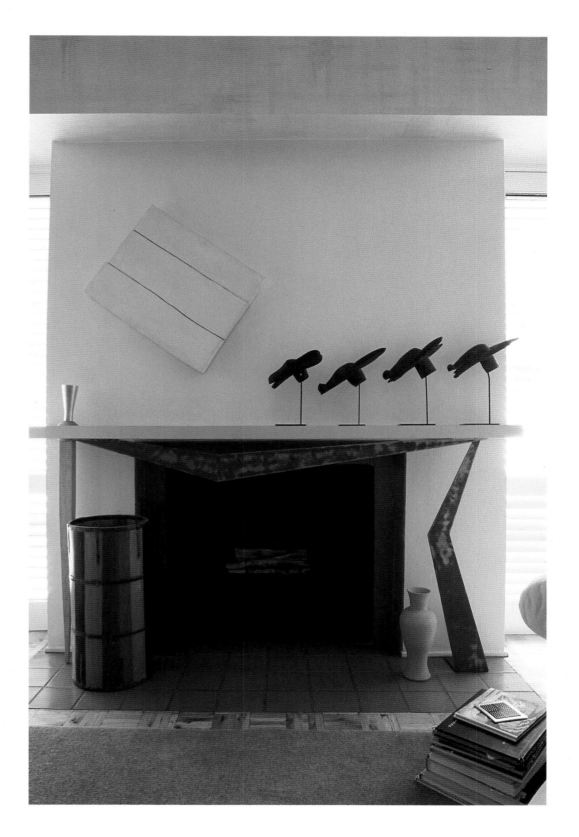

PERIOD MANTELPIECES

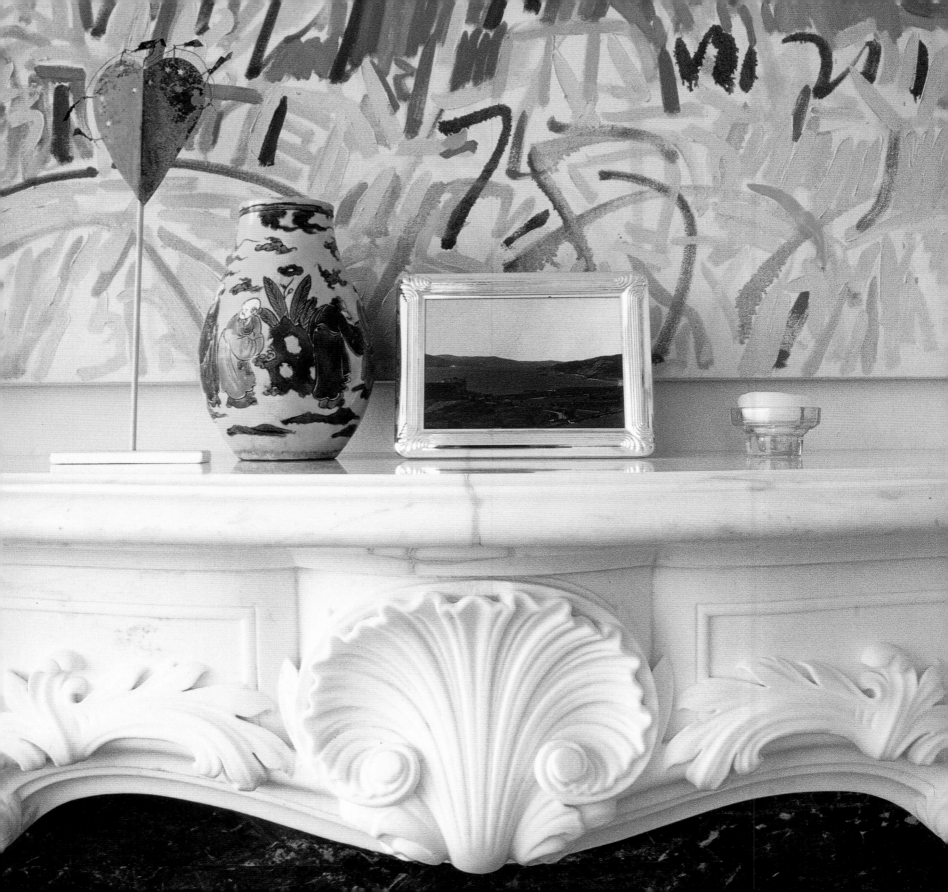

We have not been rigorous about representing every era or style, nor do we pretend to advise how and when to use an antique mantelpiece. We have merely selected a few examples to show how they can be adapted to a modern setting or used to create a sense of period style.

Starting with the sixteenth-century, when the hearth left its central position (with a hole in the roof for a chimney) of medieval times to be recessed in a wall with added hood, chimney, and flue, attention began to be paid to its decorative possibilities. As early as the sixteenth-century too, mantelpieces were being imported into England from Italy, France, Spain, and Portugal. These often featured ornately carved or ornamented overmantels in wood and stone.

During the eighteenth-century, the fireplace became an integral part of the architectural scheme of a room, and greater attention was devoted to craftsmanship and design. At the beginning of the century the designs of Inigo Jones were still fashionable; later followed the ornate styles of James Gibbs and Grinling Gibbons. Later still William Kent and the Adam brothers' classically inspired versions, with columns, swags, urns, and other classical motifs, became widely popular.

In the nineteenth-century the range of fireplace designs and materials vastly expanded. Fueled by nostalgia, the Victorians developed a taste for revival, re-creating and adapting Elizabethan, medieval, and Renaissance styles. During the latter half of the century this nostalgia produced the Arts and Crafts movement, with its return to simpler forms and attention to craftsmanship. Wood, marble, slate, cast iron, and tile were among the materials used in the Victorian age, along with painted imitations of marble. This was also the age of the mass-produced fireplace. Finally, the turn of the century saw the wonderfully sinuous forms of Art Nouveau.

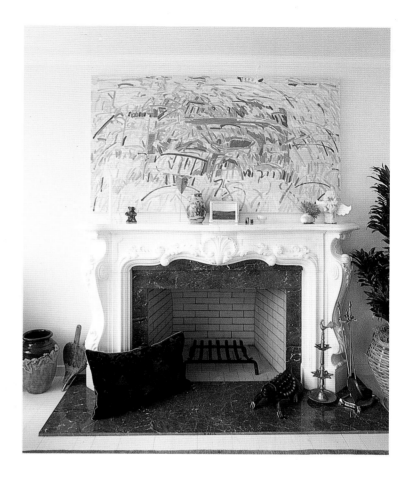

HELEN HANNA This Louis XV, white Carrara marble mantel was imported from France and doesn't look the least out of place in the living room of a San Francisco home. The owner has chosen to hang a modern painting over the mantel.

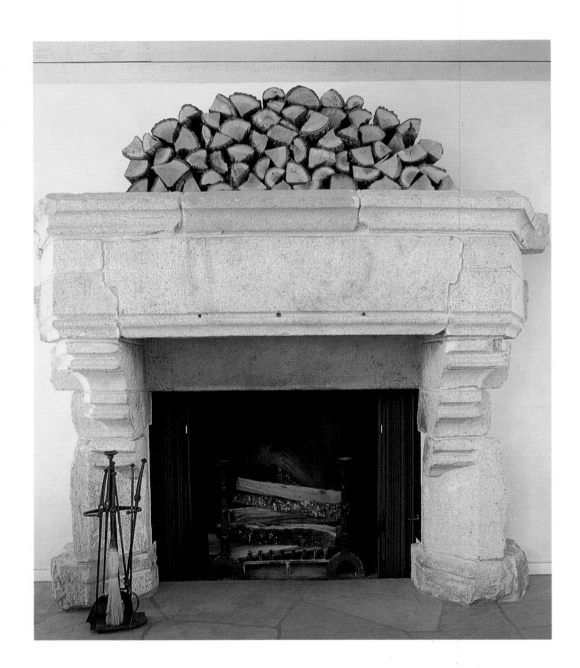

MICHAEL TAYLOR There are not many rooms that could accommodate this massive, nine-foot limestone mantelpiece imported from France by the late designer Michael Taylor, but surmounted by an equally imposing pile of logs, it looks right at home in the living room of this large, rambling country home built by architect Sandy Walker. The hearth is constructed of stone pavers.

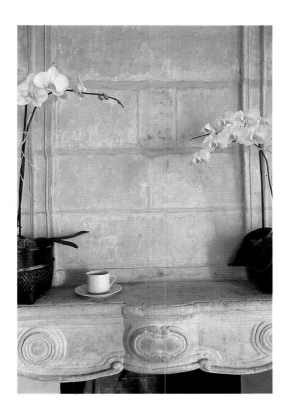

SUZANNE TUCKER

Designer Suzanne Tucker likes to describe her own style as favoring the traditional with a contemporary flair, a style well reflected here in the fireplace of her dining room. Originally from a French chateau, this pretty Louis Quinze Caen stone mantelpiece and *trumeau* perfectly complements its pickled-oak setting. Tucker set the *trumeau* flush with the wall, fitting the molding around it to get more depth from the mantel. The fireplace is flanked by blind doors behind which the owner stores china and glass. With the recessed lighting behind the moldings falling on the *trumeau,* the effect at night is particularly pleasing.

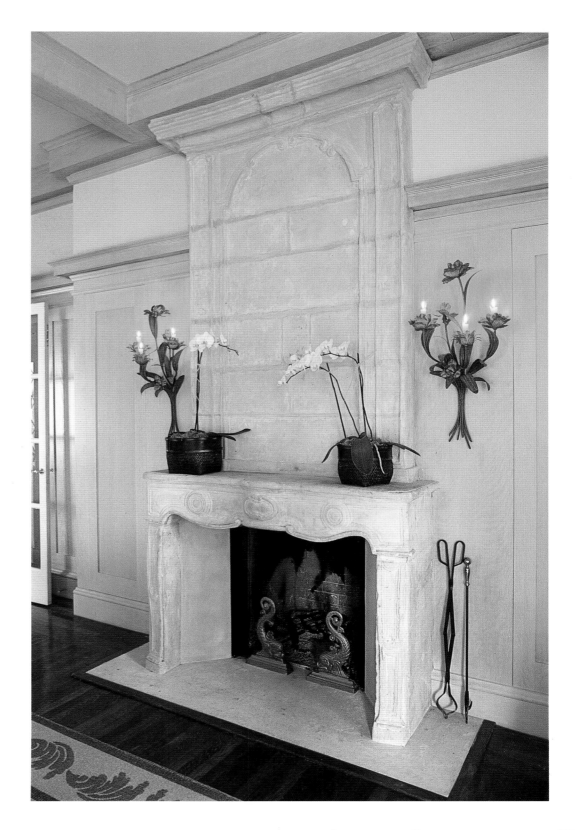

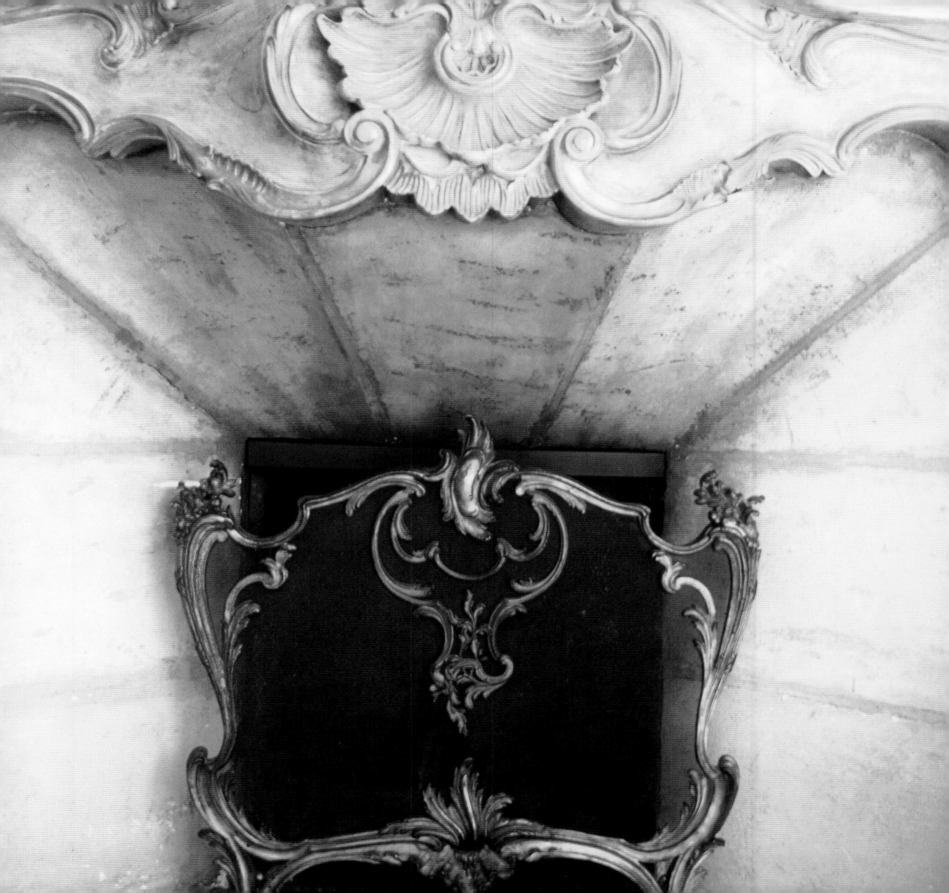

JESSICA MCCLINTOCK

Upon purchase of her home, clothing designer Jessica McClintock, with the help of designer Dian Burn, transformed the dark Victorian interiors into a light-infused realm imbued with an eighteenth-century sensibility in keeping with the romantic nature of her designs. The house is filled with sumptuously upholstered eighteenth- and nineteenth-century furniture, lace, and silks, set against a background of ivory walls, hand-painted murals, bleached floors, and antique boiserie. Artist Bill Sullivan from New York crafted this wooden fireplace for the diningroom; its sinuous curves, outlined in gilt, were inspired by the baroque Austrian mirror with its accompanying birds.

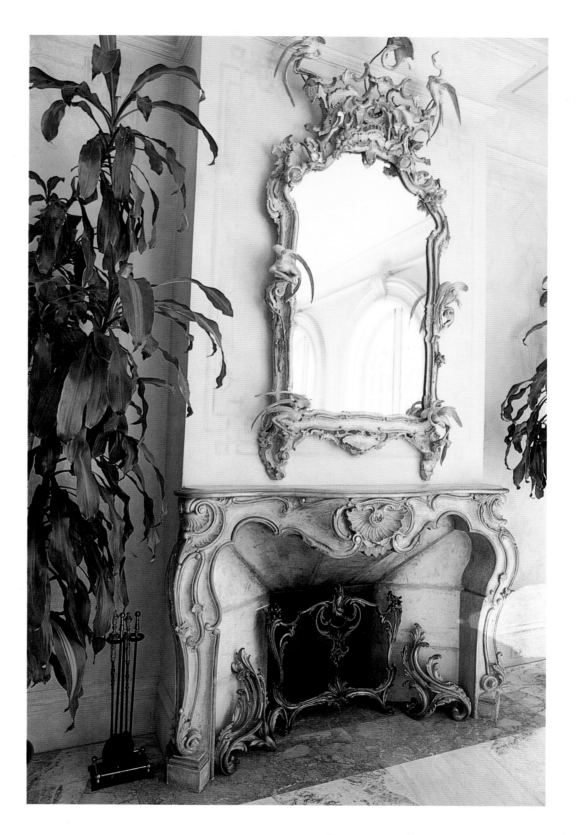

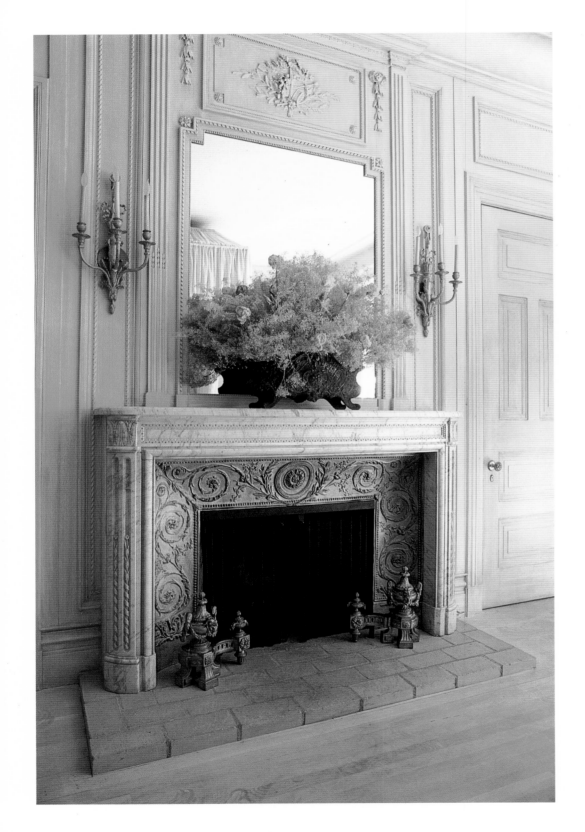

JESSICA MCCLINTOCK

Period fireplace expert and antique store owner Charles Gaylord furnished McClintock with this elegant Belgian beige marble mantelpiece and nineteenth-century ornately worked metal firesurround, also known as a "cut-down." It was used when coal was available and smaller fireboxes were more appropriate. The mantelpiece, which graces a guest bedroom, is set on a raised hearth which Gaylord will point out for authenticity, should be flush with the floor.

For the diningroom of the same house, this reproduction mantelpiece is a perfect companion to the mirror with its flower garland motif. The mantelpiece is painted a delicate shade of aqua green, echoing the wall treatment.

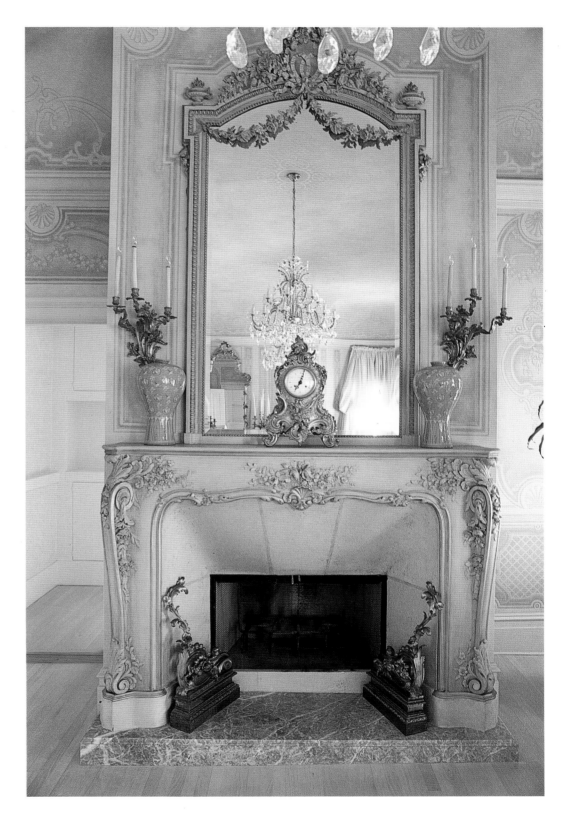

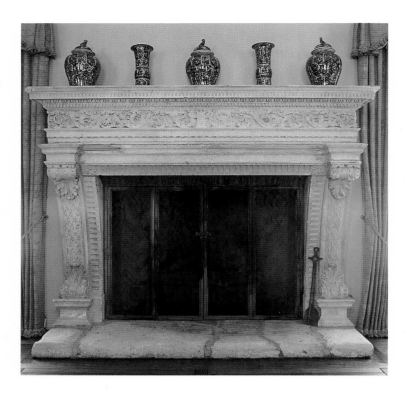

EDWARD GRENZBACH Architect Edward Grenzbach purchased this fine sixteenth-century Florentine mantelpiece at auction, from the vast Hearst Castle inventory. It has found a fitting home in the music room of a house belonging to an accomplished amateur viola player. This splendid room has hosted such luminaries of the music world as Yehudi Menuhin and Isaac Stern. The frieze cornice is an adroit example of trompe l'oeil, repeating the pattern of the mantelpiece relief. The gilt chairs are sixteenth-century, most recently from the Florence home of Helena Rubinstein.

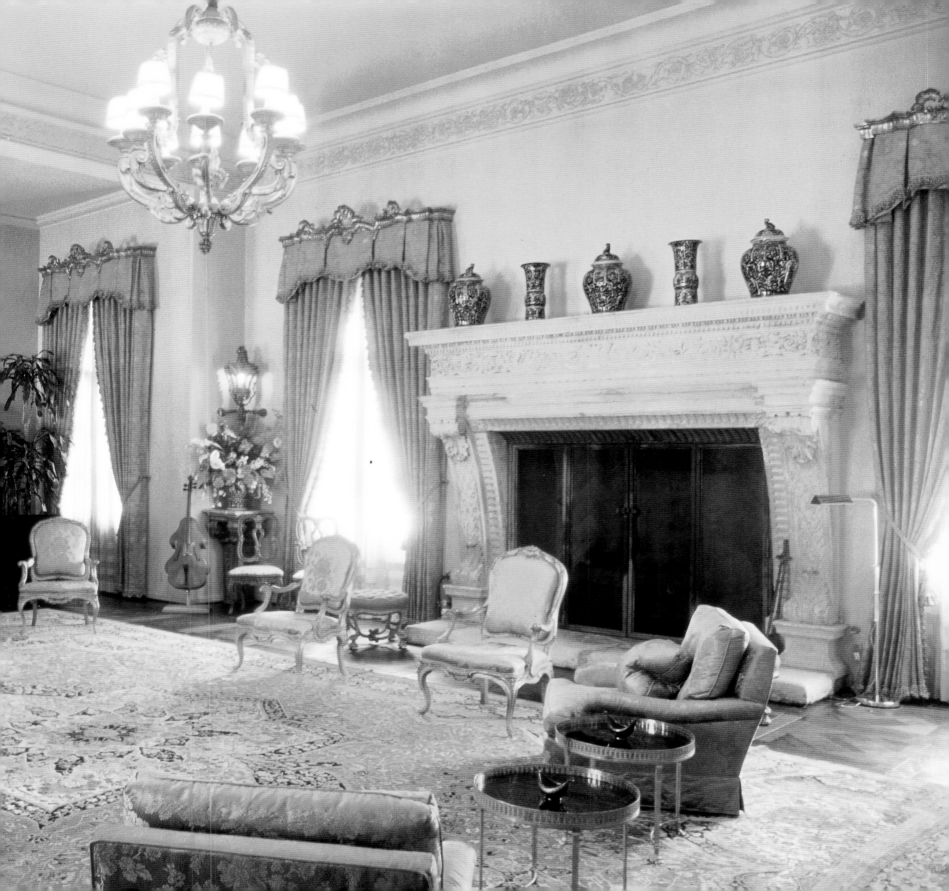

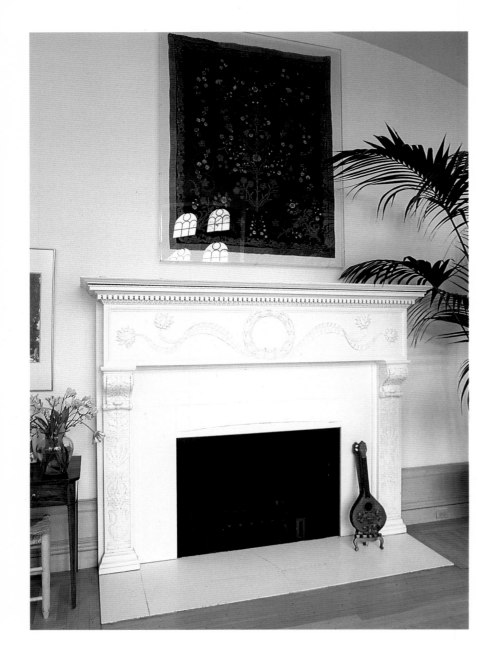

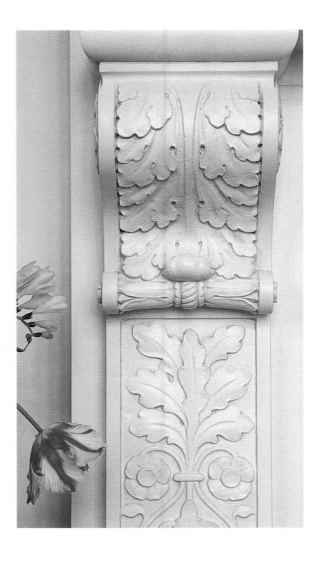

HELEN HANNA This classical motif fireplace came from the St. Francis Hotel in San Francisco. Originally black lacquer, it is now painted white. The unusual bellows in the shape of a lute are the work of George Kessler, who transforms this humble fire tool into such varied musical instrument forms as lyres, guitars, and even Japanese biwas.

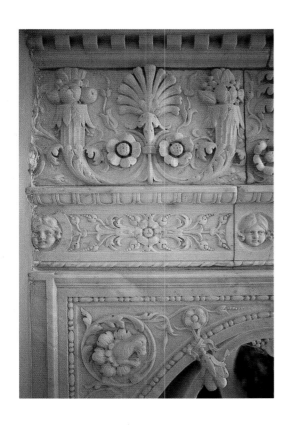

DIAN BURN

This impressive seventeenth century-style Italian fireplace was the only feature designer Dian Burn preserved in the livingroom of her Southern California home. Burn flanked the exteriors with mirrors for light and dressed the mantel with an antique French sundial and a pair of antique Venetian wood figures.

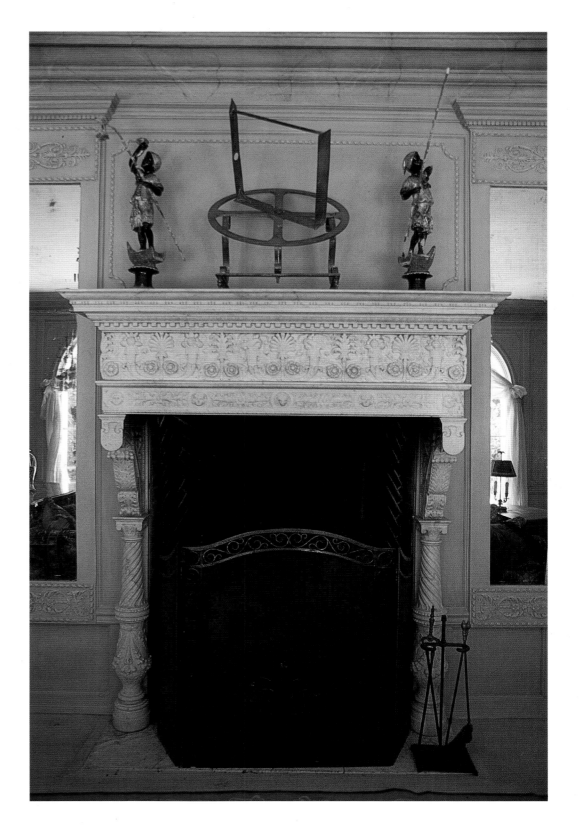

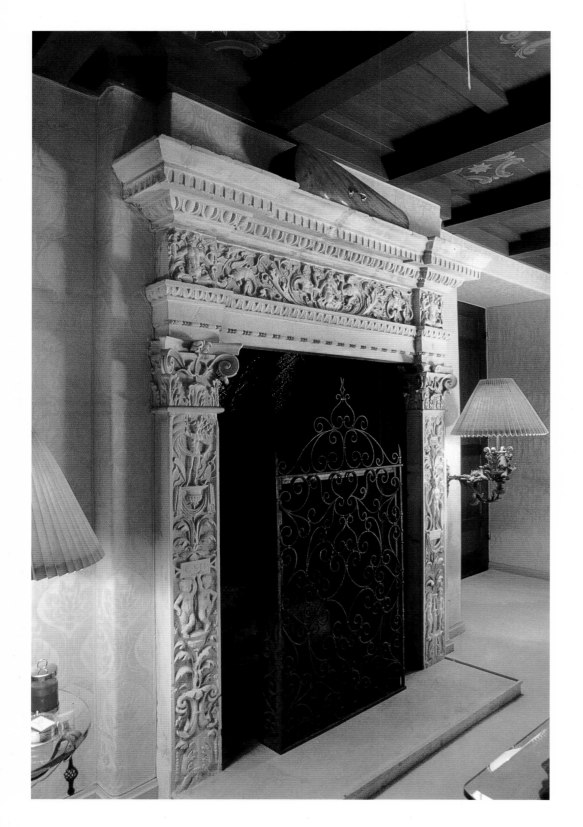

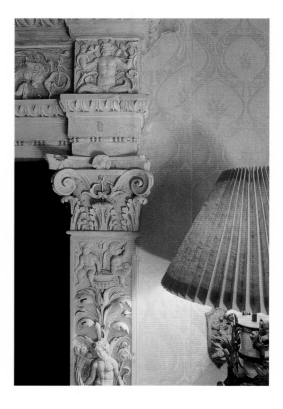

EDWARD GRENZBACH

Grenzbach, who has a fondness for tall mantelpieces, found this classical Italian example over five feet high in an auction. The mantelpiece is cut stone, ornately worked, with eminently appealing dimensions. The fire screen, which matches the mantelpiece in its ornateness, is actually an adapted window grill. The sconce is the work of contemporary ironworker Vivian Dunne.

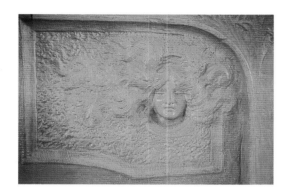

JACKSON COURT

The Jackson Court Hotel was converted from a private house in San Francisco built in 1900. This fireplace, in what is now the lobby, is a marvelous example of Victoriana, with its crouching cherubs, symbols of the east and west winds, and images in the top-heavy mantel representing (according to manager Pat Cremer, who quizzed the former owner) male and female energy. Cremer acknowledges that the fireplace attracts a lot of attention and adds that it is an extremely efficient producer of heat.

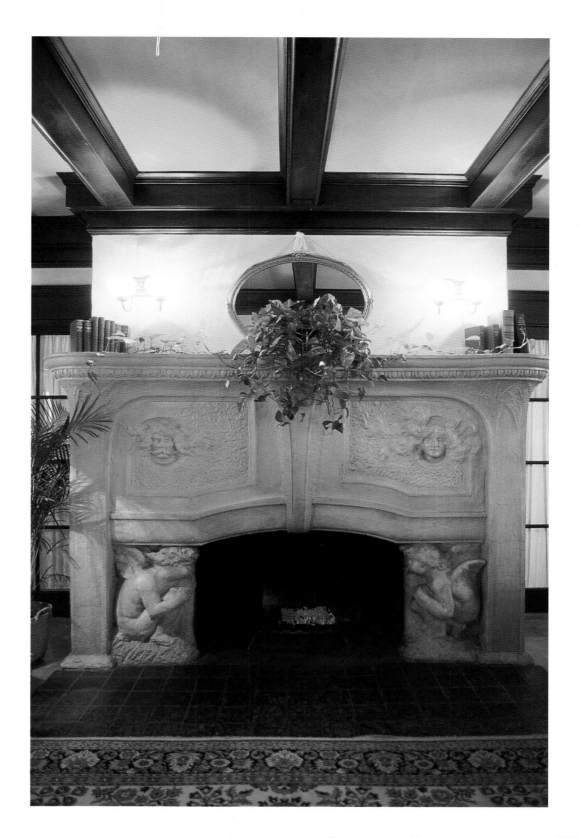

THE WELL-DRESSED MANTEL

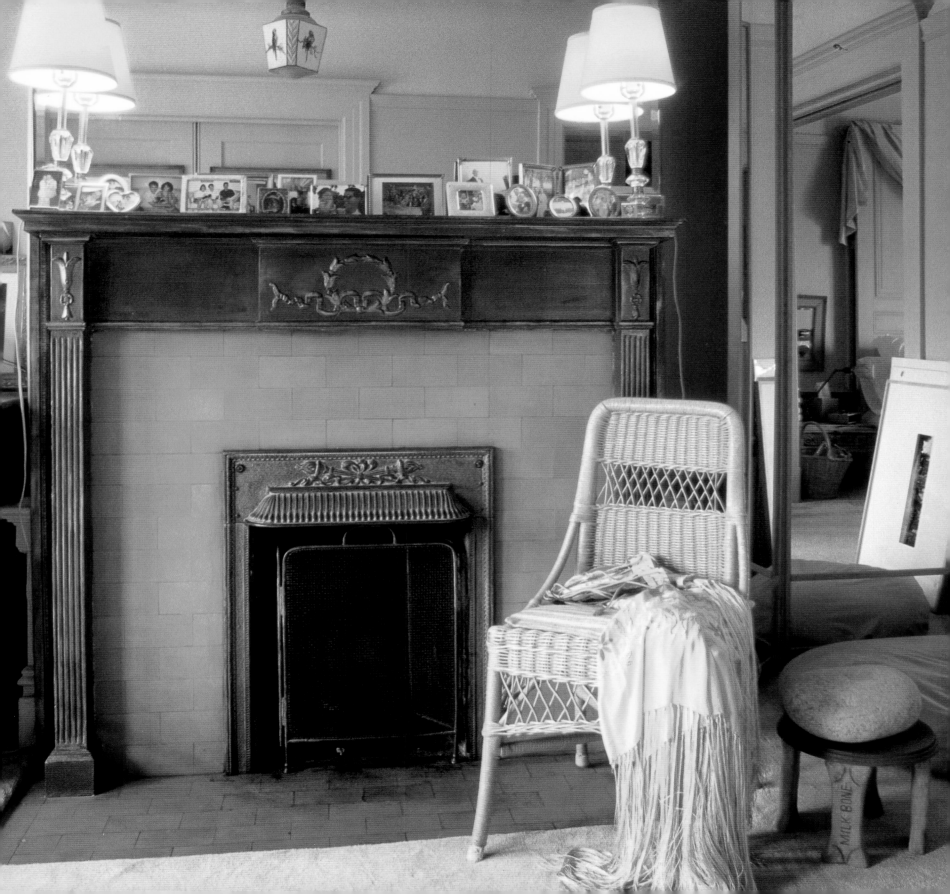

Whatever style of mantelpiece we choose for ourselves—or inherit—whether classic or contemporary, it will become a fixed element in the room, most likely providing the main focus. It is dressing a fireplace that can afford us some measure of self-expression. A complete change of mood can be effected by the choice of objects chosen to accompany a fireplace.

The mantel, usually a shelf projecting from the firesurround, is an open invitation for decoration. Acting as a stage set in miniature, it can provide a backdrop for an array of props that change with the season, according to decorating style, or simply on a whim. Some fireplaces are so modest or downright plain that dressing is of paramount importance. Others, contemporary or antique, are starring attractions on their own, needing little or no embellishing.

We have highlighted some mantels to demonstrate what can be achieved with judicious juxtaposition, sometimes pared down, sometimes cluttered, sometimes in complete contrast to period and style, sometimes complementary. Be they objets trouvés or custom-made, photographs of sentimental or artistic value, an artfully tossed pair of shoes, or simply flowers, dried or fresh, no sources need be overlooked.

We also asked some designers to showcase their own talents by coming up with different treatments of the same fireplace, demonstrating what can be achieved with a little imagination and a few props.

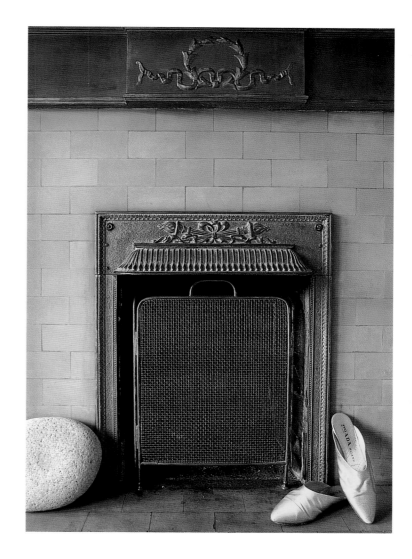

ANN JONES An existing firesurround in the study of interior designer Ann Jones was given a faux bronze treatment to match the grate by painter Brent Cross. The designer has chosen to dress the mantel with a collection of family photos in silver frames.

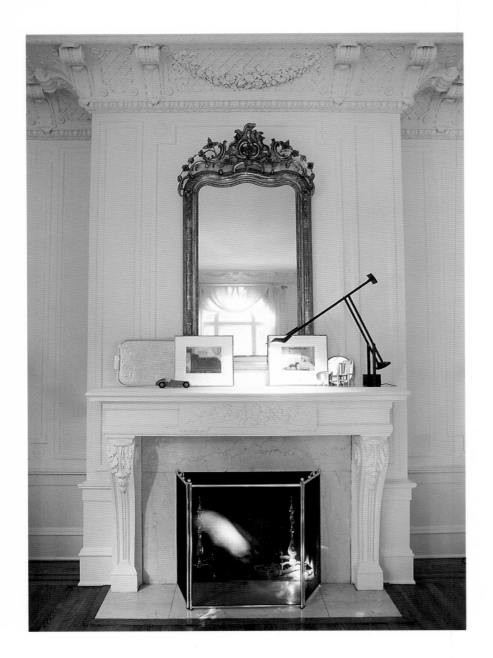

ANN JONES Showing a more restrained side, using another mantel, Jones sets up a coolly pleasing tableau of a pair of black-and-white photographs by Seattle artist Marsha Burns, accompanied by a set of miniature tin furniture, a mirror, and a tin tray.

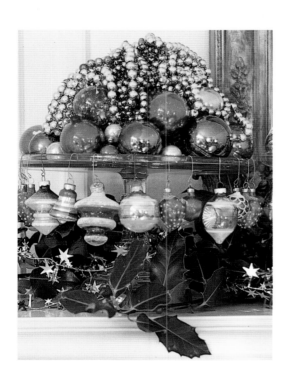

When asked to come up with a Christmas theme, Jones took great delight in concocting a typically playful and witty variation. The designer admits to a weakness for Christmas ornaments, from antique to kitsch. Drawing upon her extensive collection, she piled treasured antique glass cake stands with dollops of colored balls, hanging them on the rims and draping them with colored beads in an Edwardian orgy of excess.

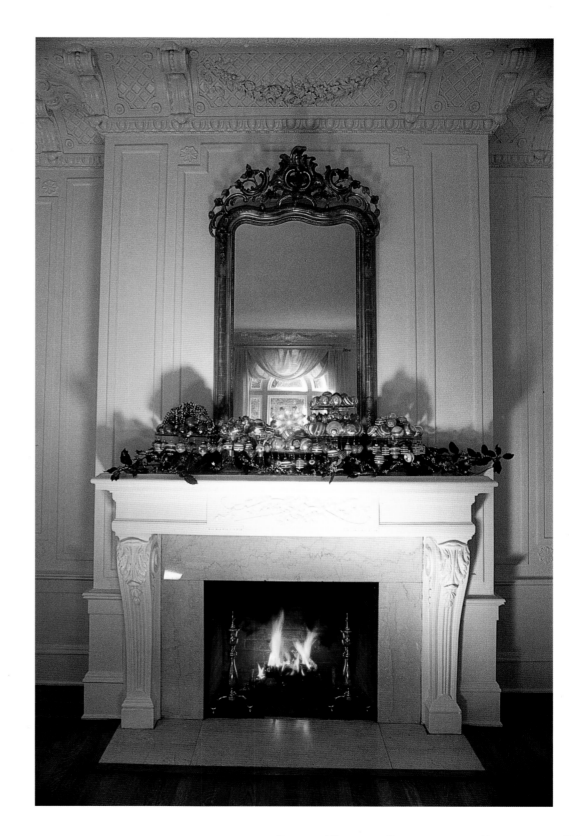

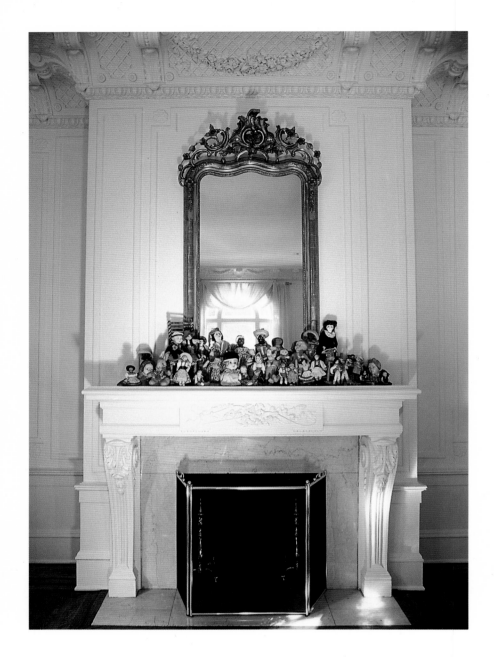

ANN JONES Jones also possesses a large collection
of dolls from all over the world, which
she used to decorate the same mantel.

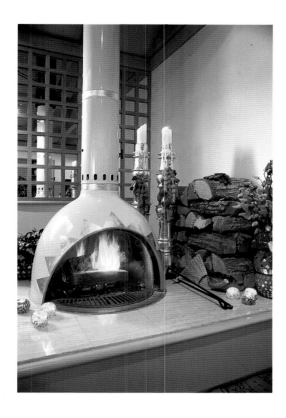

NICK PETERS

Nick Peters, a designer specializing in window dressing, allows his playful side full rein when it comes to decorating his own wood-burning stove. In this incarnation it is a "summer fireplace"; Peters has clothed the hood of the fire with a grass skirt from Maui to accompany a collection of objects, each evoking summer: sunflowers, giant Mexican candle holders, a hand-thrown pot adorned by a clay chameleon, and a museum-bought gourd. With a liberal application of gold paint, glass votive candle holders, and an inviting pile of logs, Peters transforms his wood-burning stove with a Christmas theme.

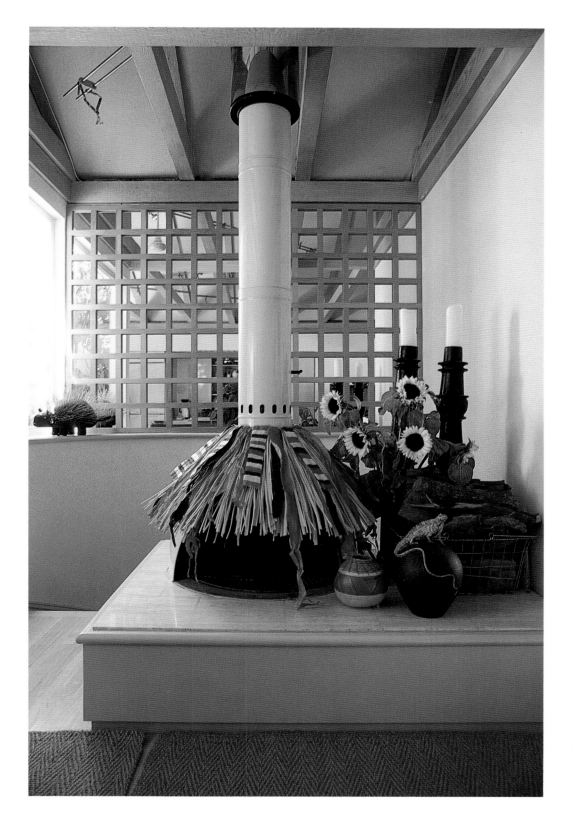

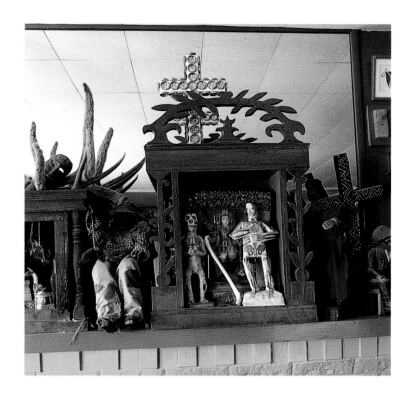

LOPEZ & BOK The owners of this exuberant fireplace, Jon Bok and Robert Lopez, make equally innovative naif furniture from such workaday materials as colored buttons and beaten tin. Inveterate travelers, the pair collect folk art and inspiration from forays to South America. Evidence of their collection is crowded —and that is perhaps an understatement—around the colorfully painted hearth: papier-mâché figures, paper flowers, Mexican Day of the Dead figurines, and an impressively lively example of taxidermy (Jon Bok's interest) featuring Bob the dog. In a fitting touch, during the summer months, the firebox is filled with a collection of bones.

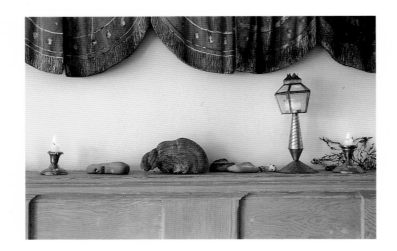

LANDENBERGER & WATERMAN

Designers Brett Landenberger and Scott Waterman have a passion for architectural objets trouvés, with which, in differing treatments, they dress their wooden mantelpieces. Here Brett and Scott have hung a carved wooden altar drapery, in various stages of restoration, over the fireplace. The screen was hand-painted with a fourteenth-century damask pattern by Scott.

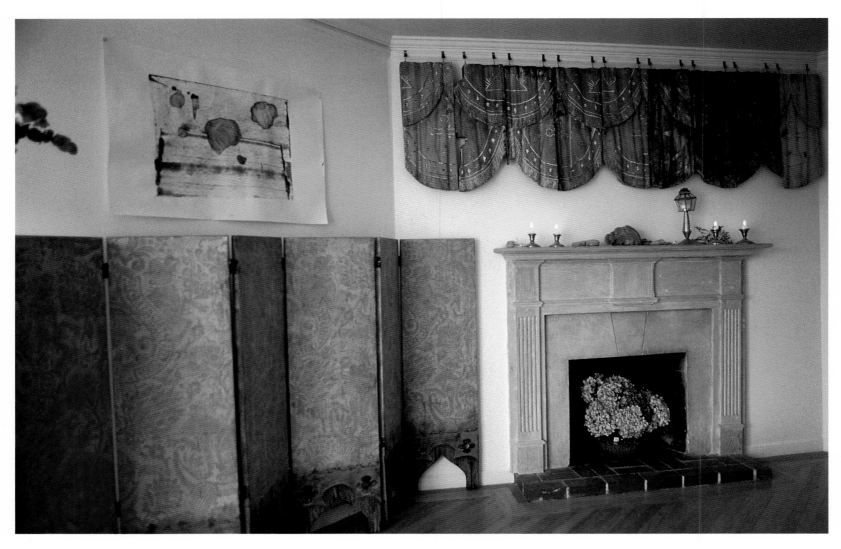

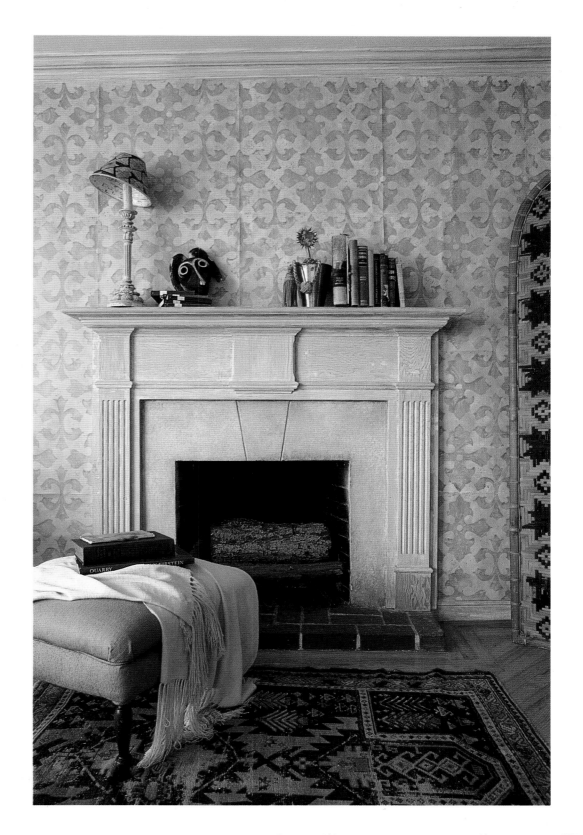

In a softer incarnation, Brett papered the wall with his own handmade paper and dressed the mantel with deliberate informality. An upholstered stool is drawn close to the fireplace and placed on a rug, an arrangement that seems to find approval with Mimi, the resident cat.

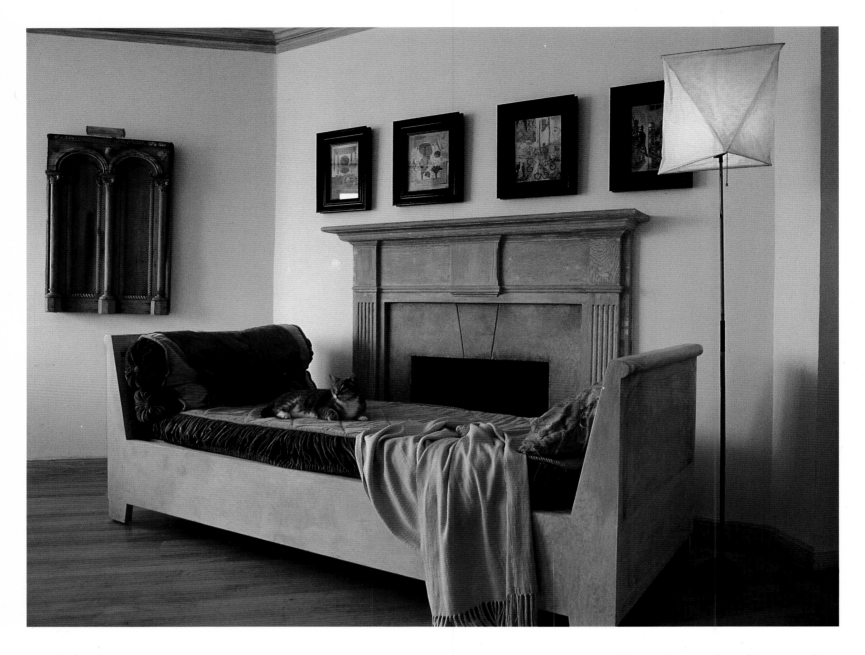

LANDENBERGER & WATERMAN In a rather more formal treatment, four of Scott's framed collages hang over a bare mantelpiece, balanced stage left by a remnant of a choir stall that came from a church in Montreal. A *recamier* with cushions of antique material is invitingly placed directly in front of the fireplace. The cool classicism of this treatment makes for a pleasing tableau.

The fireplace between scenes.

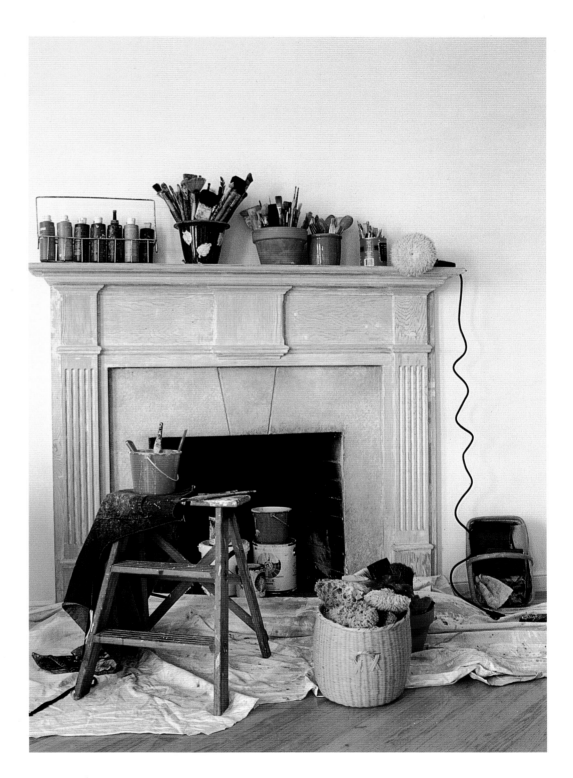

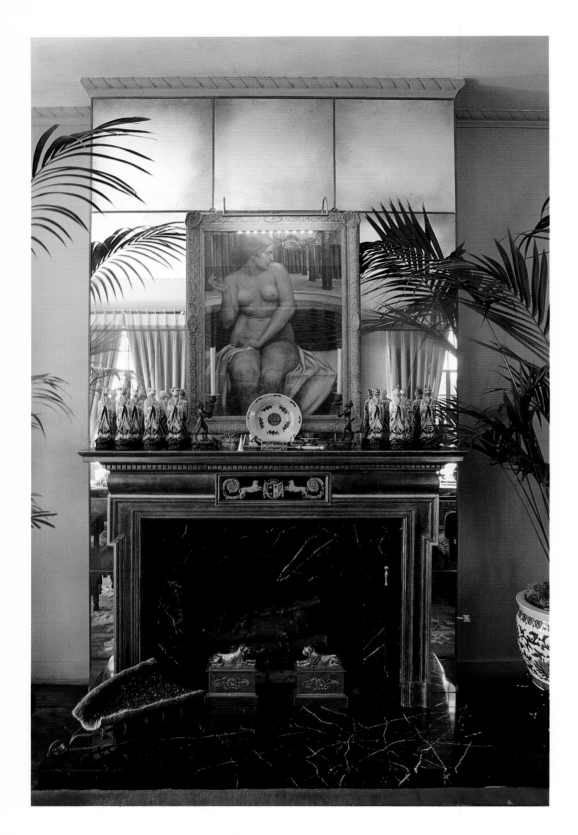

VINCENT JACQUART

In a richly appointed living room of the Hollywood home of Dr. Paul Keith III, designer Vincent Jacquart gives the fireplace a similar lush treatment. An ordinary wooden mantel was given a faux finish by painter Jeff Turner, using silver leaf. The panthers on the cartouche are a reference to the former owner of the house, Bela Lugosi, who kept the animals; the crown symbolizes his role as Dracula. Jacquart set the mantelpiece against oxidized mirror panels and used black marble for the firesurround. The andirons are French Directoire. An amethyst, which the designer explains were always placed by fireplaces for light in Europe, rests on a base on the hearth.

MICHAEL MOORE

In a Designers' Showcase House, San Francisco interior designer Michael Moore was asked to furnish a music room paneled with warm wood. He placed a painted screen by Scott Waterman in front of the firebox and hung a gold-painted convex mirror, inspired by John Sloane, over the faux black marble mantelpiece.

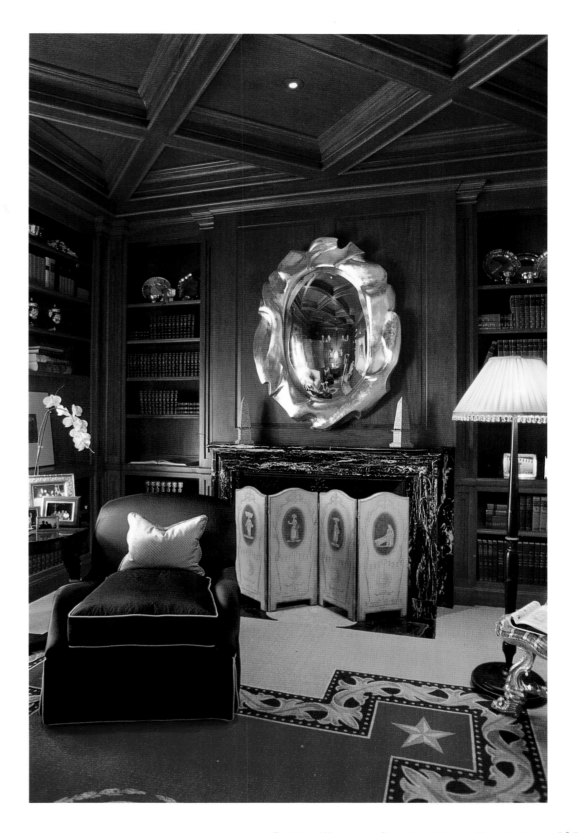

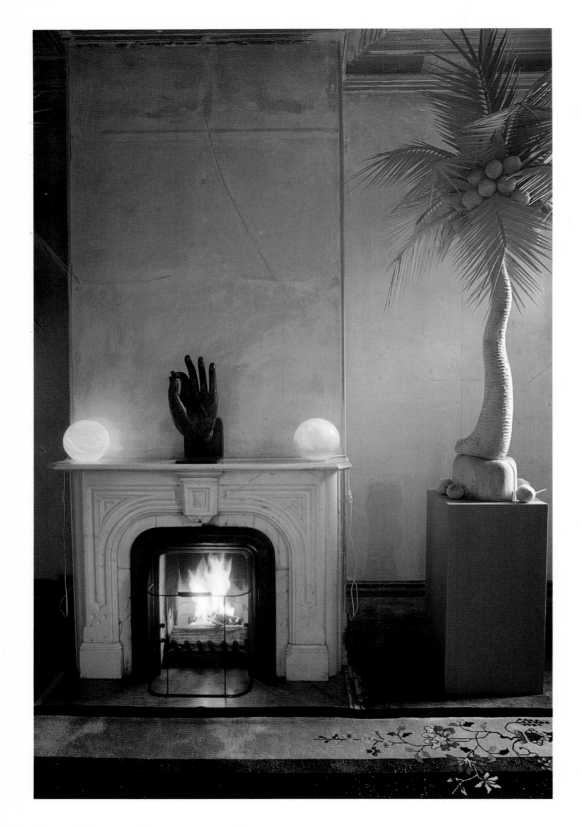

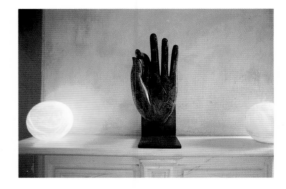

EVANS & BROWN

Artists Mark Evans and Charley Brown live in a roomy Victorian which according to Evans is in a constant state of evolution. The house, whose walls they have stripped and to date left unpainted, has a dreamy air of mystery tinged with a subtle surrealism, enhanced by an eclectic range of objets d'art and Brown's canvases. The fireplaces are the usual generic Victorian marble versions, making a suitably understated background for the owners' stylish treatments. In the dining room two carved wood palm trees flank a mantel dressed simply with a bronze hand from Cambodia and a pair of alabaster spheres. "I particularly like their curves, which are sort of Regency," says Evans of the two sentinel-like trees. The black hand raised as if in benediction forms a serene centerpiece.

THE GARDENER

This fireplace, tucked into a corner of The Gardener, a fine gardening store in Berkeley, makes for a useful display case for some of the store's eclectic wares, its muted tones offering a neutral backdrop. Owner Alta Tingle explains that although the store didn't originally feature a fireplace, she felt one was necessary considering the importance a hearth occupies in a home. The store, which aims through its merchandise to present a merging of indoor and outdoor worlds, was designed to reflect this blending, using simple materials arranged with a degree of sophistication.

RESOURCES

Architects

Ace Architects
330 Second Street
Oakland, CA 94607
510-452-0775

BAM
1422 Second Street
Santa Monica, CA 90401
310-393-3252

Cheng Designs
1210 Seventh Street
Berkeley, CA 94710
510-524-4012

Cody, Tad
Cody Associates Inc.
941 Emerson Street
Palo Alto, CA 94301
415-328-1818

Envision Architecture
555 De Haro Studio 120
San Francisco, CA 94107
415-864-5482

Fernau & Hartman, Architects
2512 Eighth Street
Berkeley, CA 94710
510-848-4480

Fisher, Frederick, Architect
2048 Broadway
Santa Monica, CA 90404
310-828-3663

Frost, Tsuji, Architects
915 Battery Street
San Francisco, CA 94111
415-421-9339

Grenzbach, Edward, Architect
8742 Holloway Drive
Los Angeles, CA 90069
213-652-7240

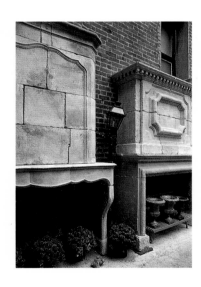

Harris, Michael, Architect
347 Bryant Street
San Francisco, CA 94104
415-243-8272

Hayne, Robbin, Architects
6162 La Gloria Drive
Malibu, CA 90265
213-457-0732

House, Steven & Cathi
House + House
1499 Washington Street
San Francisco, CA 94109
415-474-2112

Israel, Frank, Architect
254 S. Robertson, Suite 205
Beverly Hills, CA 90211
310-652-8087

Kurlander, Ira
1403 Schrader Street
San Francisco, CA 94117
415-564-9937

Levy, Toby
26 South Park
San Francisco, CA 94107
415-777-1164

Liebermann, Daniel J B-H
2728 Benvenue
Berkeley, CA 94705
510-548-5298

Moore, Ruble & Yudell
933 Pico Boulevard
Santa Monica, CA 90405
310-450-1400

Ojeda, Rubin
8444 Wilshire Boulevard
Beverly Hills, CA 90211
213-852-1465

Ortega, Luis
Design Studio
8813 Rangely Avenue, Suite 3
Los Angeles, CA 90048
213-273-2040

Rex, Michael, Associates
339 Caledonia Street
Sausalito, CA 94965
415-331-1400

Servais, James & Gillian
Servais Design & Construction
1150 Westview Drive
Berkeley, CA 94705
510-548-8453

Solomon, Daniel, & Associates
84 Vandewater Street
San Francisco, CA 94133
415-397-9190

Walker & Moody, AIA
2666 Hyde Street
San Francisco, CA 94109
415-885-0800

Artists

Chodko, Dana
Noonan Building
Pier 70
San Francisco, CA 94107
415-552-4410

Evans & Brown
34-50 Third Street, Unit 1D
San Francisco, CA 74124
415-648-9430

Hosh, Mike
1121 Cabrillo Avenue
Venice, CA 90291
310-392-1777

Linder, Karin
629 E. 6th Street, 5th Floor
New York, NY 10009
212-598-0559

Marchiori, Carlo
357 Frederick Street
San Francisco, CA 94117
415-564-6671

Thompson, Karen
Archetile
334 S. Van Ness Avenue
San Francisco, CA 94103
415-863-1594

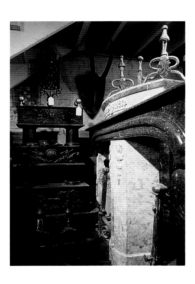

Interior Designers

Adelson, Karen
875 Portal Avenue
Oakland, CA 94610
510-465-7132

Barnes, Candace
1580 Masonic Avenue
San Francisco, CA 94115
415-864-5567

Burn, Dian, Designs
One Lombard, Suite 306
San Francisco, CA 94111
415-956-3640

Chase, Linda
3415 Tareco Drive
Los Angeles, CA 90068
213-969-8423

Hall, Shawn
235 Greenwich Street
San Francisco, CA 94133
415-986-3518

Hutchinson, Robert, Designs
1232 Sutter Street
San Francisco, CA 94109
415-771-7000

Jacquart, Vincent
706 Heliotrope Drive
Los Angeles, CA 90029
213-667-1150

Jones, Ann, Interiors
2629 Clay Street
San Francisco, CA 94115
415-346-8385

Landenberger, Brett
Waterman, Scott
2707 Judah Street
San Francisco, CA 94122
415-664-8015

Moore, Michael
2100 Jackson Street
San Francisco, CA 94115
415-567-7955

Myers, Ron
7711 Fountain Avenue
Los Angeles, CA 90046
213-851-7576

Rowe, Van-Martin
195 Parkwood Avenue
Pasadena, CA 91107
818-577-4736

Tucker & Marks
3352 Sacramento Street
San Francisco, CA 94118
415-931-3352

Wilder, Jo,
Design Collection
8380 Waring Avenue
Los Angeles, CA 90069
213-655-6545

Wiseman, Paul Vincent
Interior Design, Inc.
636 San Bruno Avenue
San Francisco, CA 94110
415-282-2880

Fabricators

Bidstrup, Darell
508 Fulton
Salmon, ID 63467

Malm Fireplaces Inc.
368 Yolanda Avenue
Santa Rosa, CA 95404
707-523-7747

Johannes
Marbelous Inc.
1055 Natoma Street
San Francisco, CA 94103
415-864-3648

Palos, Manuel Sculpture
1330 Donner Avenue
San Francisco, CA 94124
415-822-8034

Petersen, Norman
350 Treat Street
San Francisco, CA 94110
415-431-1100

Sullivan, Bill
70 Richardson Boulevard
Brooklyn, NY 11211
718-387-0367

Miscellaneous

Artefacts
117 Pixley Street
San Francisco, CA 94123
415-921-5439

Forristt, Cevan, Designs
345 S. Nineteenth Street
San Jose, CA 95116
408-297-8538

Gaylord, Charles
European Antiques.Mantels.Garden Furniture
2151 Powell Street
San Francisco, CA 94133
415-392-6085

Kessler, George W.
Gusty Winds
P.O. Box 2004
Burlingame, CA 94011
415-697-9105

Wibroe, Susanne
626 Locust
Sausalito, CA 94965
415-332-0543

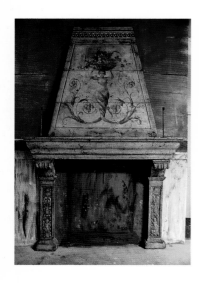

Varriale, Roberto
1345 Underwood Avenue
San Francisco, CA 94124
415-822-2346

GLOSSARY

Aga A closed iron range fueled by coke, oil, or gas.

Coving Angled sides of firebox.

Dentils A small square block used in series in Ionic, Corinthian, Composite, and, more rarely, Doric cornices.

Firesurround Shelf and side elements framing a fireplace. Also called chimneypiece or mantelpiece.

Firebox The box or chamber containing the fire of a furnace or fireplace.

Hearth The paved or tiled floor of a fireplace.

Hood The canopy overhanging a fireplace to increase the draft.

Jamb The side elements of a firesurround supporting a mantel.

Rumford fireplace A fireplace specially constructed to maximize heat output and minimize smoke problems developed by Sir Benjamin Thompson, Count Rumford (an American), in the eighteenth century.

Trumeau The stone mullion supporting the middle of a tympanum of a doorway.

Back cover: With a deft structuring of angles planes, color, and texture, architect Frederick Fisher achieves a feeling of lightness in a cone-shaped design fireplace of plywood and nickel-detail plaster (upper left). Sculptor Bill Sullivan created this eighteenth-century reproduction Italian-style mantelpiece for the richly appointed music room in clothing designer Jessica McClintock's San Franciscan Victorian home (upper right). In the guest cottage of the Beverly Hills home of Dr. Paul Keith III, designer Vincent Jacquart devised an ingenious firesurround that simultaneously houses a working fire and an aquarium (lower left). This baronial-looking fireplace is the work of architect Bernard Maybeck, designer of the Palace of Fine Arts for the 1915 World's Fair (lower right).